Beckmann

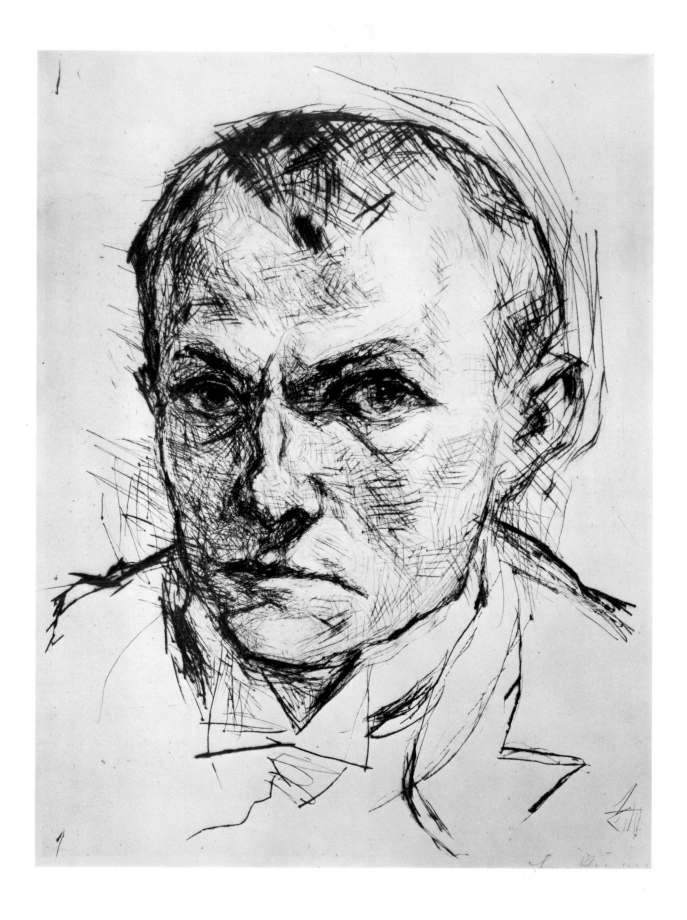

Max
Beckmann

Stephan Lackner

————————

HARRY N. ABRAMS, INC., *Publishers*, NEW YORK
1991

Frontispiece: *Self-Portrait*. 1914. Drypoint, 9⅛ x 7″

Library of Congress Cataloging-in-Publication Data

Lackner, Stephan.
 Max Beckmann / Stephan Lackner.
 p. cm.
 ISBN 0-8109-3109-5
 1. Beckmann, Max, 1884–1950—Criticism and interpretation.
 I. Title.
 ND588.B37L298 1991
 759.3—dc20 90–40845
 CIP

Published in 1991 by Harry N. Abrams, Incorporated, New York
A Times Mirror Company
This is a concise edition of Stephan Lackner's *Beckmann*, originally
published in 1977. No part of the contents of this book may be
reproduced without the written permission of the publisher

Printed and bound in Japan

Contents

Colorplates

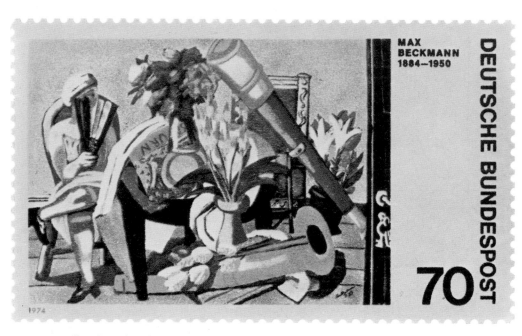

1. **Large Still Life with Telescope** by Max Beckmann is the subject of a memorial stamp issued by West Germany in 1974

Beckmann

IN THE SPIRITUAL LANDSCAPE of what might be called the Expressionist decades of twentieth-century German art, the figure of Max Beckmann looms large. His artistic personality resembles a huge boulder, deposited there by forces we do not quite understand: enigmatic, archaic, overwhelming. True, he was part of the culture of those decades—the style of his art and his life could not have developed in any other period—but he always seemed to go beyond, to point at wider horizons.

Glancing back now at those fascinating decades, one can see a unifying atmosphere, a common zeitgeist enveloping the divergent phenomena. The Expressionist philosophy came to the fore about 1905. An over-civilized society whose moral views were still beholden to the flat decency of the Victorian age suddenly discovered raw emotions, emotions not caused by catastrophes—not yet, anyway—but slumbering in the well-settled bourgeois of the day. Unsuspected depths were now boldly explored: Freud started probing the unconscious, Stravinsky broke the smooth shell of triadic harmony, and the Fauves exploded glaring volcanic colors across their idyllic landscapes. These rumblings of a coming age appeared as the willful, arbitrary outpourings of a few outsiders, and it took a long while until they were generally recognized as symptoms of a new spiritual climate.

Art was still supposed to strive for "The Beautiful." Impressionist art had conquered the surface, the sheen and the shimmer of lovely things, of fashionably dressed ladies in walled gardens, of still waters, of well-protected flowers and well-bred people. Impressionism was the product of a quietly smiling epoch. But Van Gogh, Gauguin, Edvard Munch, and James Ensor had already opened up the surface; slashing curves appeared, and the painter's brush ceased to record objective reality. Each brushstroke now expressed personal longings, ecstasies, and fears. The Fauves in France, and the Brücke and Blaue Reiter groups in Germany portrayed inner turmoil and projected it prophetically into a world that did not yet recognize its own tortured, dissolving self-portrait.

Beckmann's artistic development evolved from an Impressionist position. His early technique was akin to that of the German Impressionists Max Liebermann and Lovis Corinth, even though his subject matter was already more dramatic. He disliked the term Expressionism and, in 1912, quarreled with its early exponents, especially Franz Marc and Wassily Kandinsky, whose works he derisively called Sibiro-Bavarian religious folk-art posters (*sibirisch-haju-warische Marterln-Plakate*). That bitter discussion, carried on in well-known art magazines, left Beckmann isolated from his peers. Only from 1917 on did he find new, truly progressive forms for his pictorial ideas: anatomy and perspective were now subjected to deformations in the service of heightened expression.

Are we then, in retrospect, justified in calling him, against his will, an Expressionist?

Impressionism was a dreamless art. It knew only the present moment; myths and history were excluded from its pictures. Expressionism, on the contrary, looked everywhere for symbols to express its inner monologue. In Beckmann's oeuvre we encounter Greek deities and figures from Nordic sagas, prehistoric idols as well as stylish ladies and gentlemen, bullies and prostitutes with the typical look of the twenties and thirties; but we also find weird spirits that seem to conjure up a distant future. Beckmann's art transcends his time. This universality is the hallmark of an Expressionist.

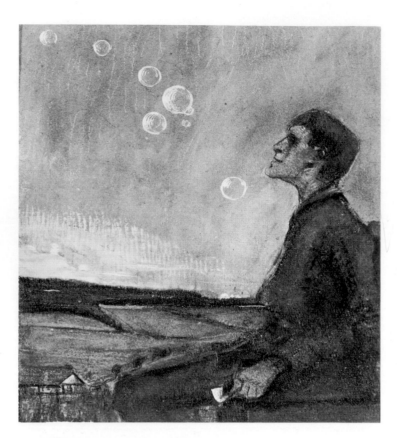

2. Self-Portrait with Soap Bubbles. *c. 1898.*
Mixed media on cardboard, 12 5/8 × 9 7/8".
Private collection, Murnau

3. Max Beckmann at the Baltic seashore, 1901

MAX BECKMANN WAS BORN in Leipzig on February 12, 1884. His father, a rather well-to-do miller and grain merchant, died when Max was only ten years old. The boy never doubted that he was destined to become a painter. "I excelled in school," he reminisced later, "by running a little picture factory whose products went from hand to hand and consoled many a poor fellow slave for a few minutes." At sixteen he wanted to apply for admission to an art academy. His guardian objected, but Max immediately drew a portrait of the man that convinced everyone of his qualifications. Beckmann was admitted to the Grandducal Art School in Weimar. Studying plaster casts and painting out-of-doors, he acquired a solid technique.

In 1903 he made his first journey to Paris, and stayed for six months. Countless later visits to that patented art metropolis produced a lifelong dialogue, a healthy, rebellious, stimulating disputation with the volatile spirit of Parisian art.

In 1904 he settled in Berlin. His first exhibitions (with the Secession group in Berlin and the Weimar Künstlerbund) were successful. A classically beautiful, almost mellifluous composition, *Young Men by the Sea* of 1905 reveals the influence of the Renaissance painter Luca Signorelli, whose work would inspire Beckmann throughout his entire artistic life (figs. 4–6). This painting brought him, in 1906, the important Villa Romana Prize; the gold coins which were counted out into his hands permitted him a winter's stay in Florence. He married a fellow student from the Weimar academy, Minna Tube. In the same year, 1906, his mother died, and he painted an excited and exciting *Death Scene* and a calmer *Death in the Family* (fig. 7). The venerated Norwegian painter Edvard Munch encouraged his young colleague to pursue this "fantastic" style. Beckmann did not follow that advice, preferring to work in a loose, flaky, naturalistic technique. However, after 1916 Munch's haunting art was to exert the most decisive influence on Beckmann's stylistic development.

His years in Berlin before World War I were happy ones. His marriage was harmonious, and in 1908 his only child, Peter, was born. Several museums and private collectors acquired his canvases, and the influential art dealer Paul Cassirer promoted his work. The Berlin Secession, an excellent and progressive artists' association, made him a director in 1910 (he resigned in 1911). In 1913 the monumental *History of Art* by Wilhelm Lübke and Friedrich Haack conferred on him this stamp of approval: "The most important one of the whole group seems to be Max Beckmann, a genuine and noble artist. Boldly he tackles great subjects. As a typical German with a penchant for idea-painting, he yet pervades his subject matter with human intimacy, with melody and rhythm." Also in 1913 a monograph, *Max Beckmann* by Hans Kaiser, appeared,

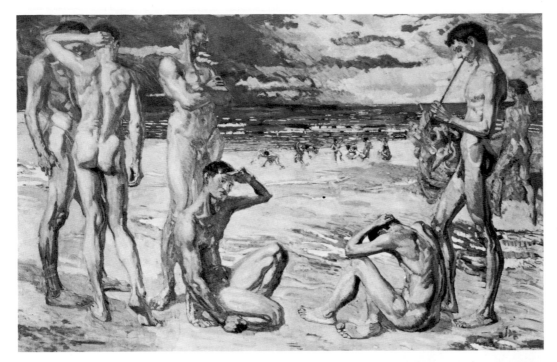

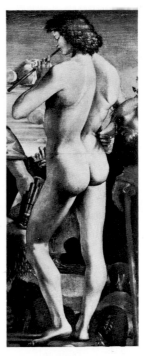

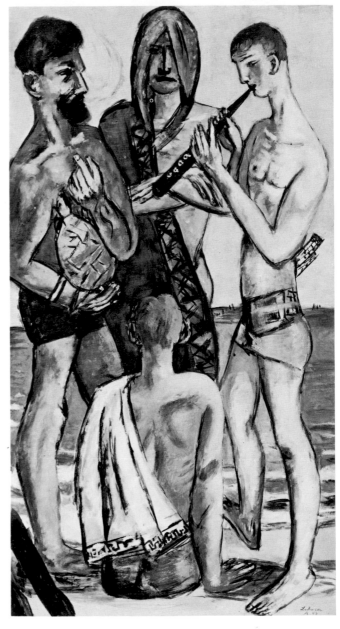

4. **Young Men by the Sea.** *1905. Oil on canvas,*
58 × 92 1/2″. Staatliche Kunstsammlungen, Weimar

above right: 5. Luca Signorelli. **School of Pan**
(detail: flute player). *Early 16th century.*
Oil on canvas, 6′ 4 1/2″ × 8′ 5″.
Kaiser Friedrich Museum, Berlin (destroyed 1945)

6. **Young Men by the Sea.** *1943. Oil on canvas,*
74 5/8 × 39 1/2″. St. Louis Art Museum

an unusual mark of recognition for an artist under thirty.

Kaiser was enthusiastic about the work of the fledgling painter. About a 1906 canvas entitled *Drama* he wrote: "With this work he becomes the 'Expressionist' of inner experiences. In it he knows no reticence, and you can see from the brushwork of the painting that it was done with the greatest emotion. A cold transcendental thrill emanates from the color." And a few pages later, Kaiser calls Beckmann "a tragic individualist"—a formulation that remains valid.

In his quest for tragic significance, the young Beckmann visualized the most horrendous catastrophes of the day. *The Destruction of Messina* (1909; fig. 9) depicts an earthquake in which an escaped prisoner stabs a policeman, and desperate half-naked people fight among smoking ruins that presage a later age. *The Sinking of the Titanic* (1912; fig. 10) presents groups of helpless humanity melting into the ocean waves. The loose, flaky technique is not yet adequate to the enormous subject matter. Did Beckmann have a subconscious urge to sharpen his tools

for formulating the horror which was to engulf the world?

The outbreak of war in 1914 found Beckmann sketching in Berlin on Unter den Linden Avenue. A Junker faced him furiously: "Why aren't you cheering, like everyone else?" Another patriot asked: "How can you draw on a day like this?" Beckmann answered: "This is the greatest national catastrophe." He barely escaped being thrashed. While other painters depicted gaily departing soldiers with bouquets at the tops of their rifles, Beckmann made a drypoint of the sorrowful face of a weeping woman.

He volunteered for service as a medical corpsman. From the Russian front he wrote to his wife Minna (October 3, 1914): "My will to live is now stronger than ever even though I have already witnessed terrible scenes and have died vicariously several times. But the oftener one dies the more intensely one lives. I kept on drawing, this secures me against death and danger." For the suspicious activity of drawing he was arrested twice; the second time he was kept under armed guard for three hours until a benevolent captain agreed that he was not a spy.

Every new impression served to deepen his artistic experience. After cleaning up an operating room he noted: "This way I'm learning to understand the feelings of a charwoman." He walked through troops of wounded

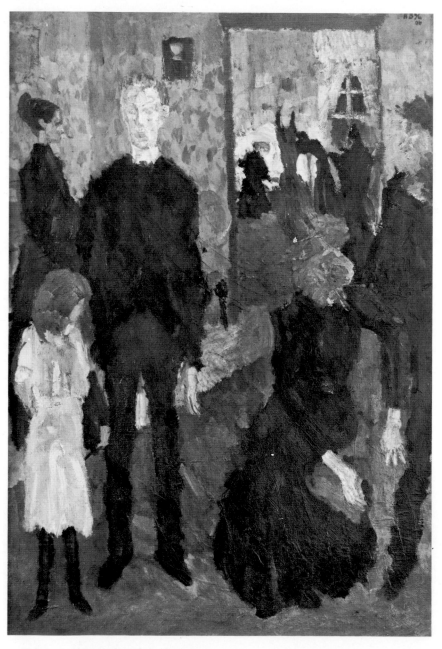

7. **Death in the Family.** *1906. Oil on canvas, 43 × 28". Nationalgalerie, Berlin*

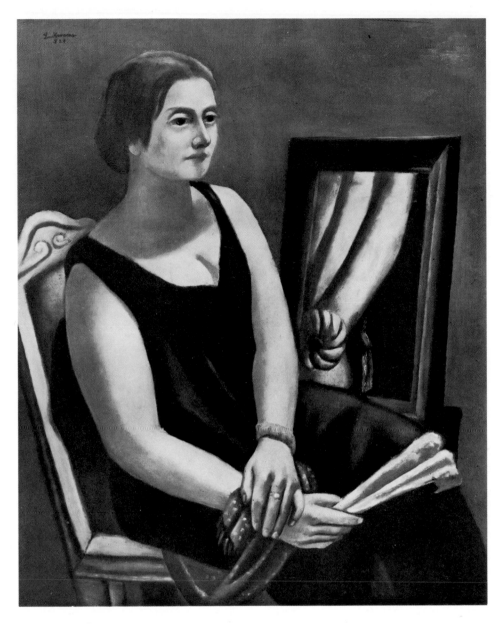

8. **Portrait of Minna Beckmann-Tube.** *1924. Oil on canvas, 36 3/8 × 28 3/4".*
Bayerische Staatsgemäldesammlungen, Munich. Günther Franke Collection

soldiers returning from the battlefield. "When the sound of a large salvo comes it is as if the gates of eternity are cleaved open. It suggests space, distance, infinity. I wish I could paint this noise. Ah, this eerily beautiful depth! Bands of humans, 'soldiers,' advance to the center of this melody, toward the decision of their lives."

On March 16, 1915, he wrote to his wife from Flanders: "Yesterday I was off duty. Instead of relaxing I savagely delved into drawing and worked for seven hours on a self-portrait. I hope to become ever more simple, more concentrated in my expression. Wonderful to me is the encounter with people. I have a mad passion for this species."

One of his most characteristic utterances occurs in a letter of April 21, 1915: "Often I'm amused by my own idiotically tough will to live. I spit, choke, shove, crowd through, I must live and will live. Never, by God, have I stooped in order to have success. But I would squeeze through all the sewers of the world, through all forms of debasement and defilement just in order to paint. I must do that. Down to the last drop all my imagination of living forms must be squeezed out of me, then it will be a pleasure to get rid of this damned torture."

Many of his wartime drawings have survived, as well as a single oil: a 1915 *Self-Portrait as a Medical Corpsman* (colorplate 2) with searching eyes and a red cross on the uniform collar. After a complete nervous collapse Beckmann was discharged. He moved to Frankfurt am Main.

World War I appeared to be an unmitigated disaster for

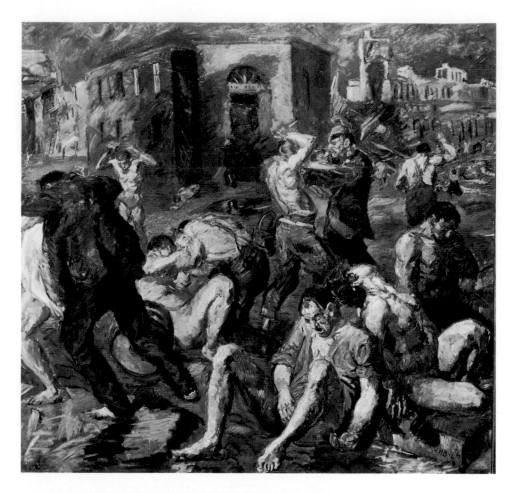

9. **The Destruction of Messina.**
1909. Oil on canvas,
7' 15 1/2" × 8' 7".
Collection Morton D. May,
St. Louis

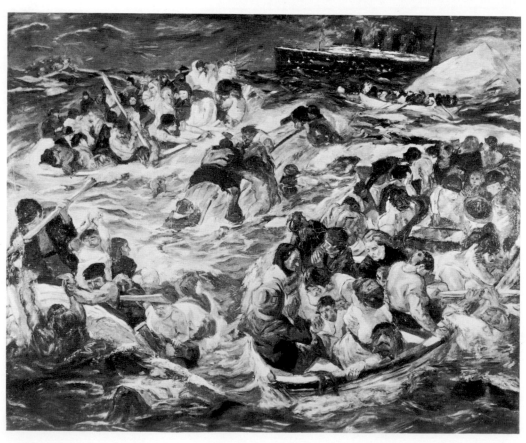

10. **The Sinking of the Titanic.**
1912. Oil on canvas,
8' 8 1/2" × 10' 10".
Collection Morton D. May,
St. Louis

14

German art. Before the war, progressively minded young German painters had been pupils of Matisse in France; other painters working in France such as Picasso, Braque, Delaunay, and Vlaminck had exhibited their works in Germany, in close contact with their German colleagues. Expressionism acknowledged no national boundaries; Italian Futurism and Russian Abstraction—which later on was formulated as Suprematism—exerted fascinating influences on the German avant-garde, and vice versa. But in August 1914 all these crosscurrents were suddenly cut off.

Beckmann refused to be infected by chauvinism. At the outbreak of war he had said to his wife Minna: "I won't shoot at Frenchmen, I owe too much to Cézanne. And at Russians neither: Dostoyevsky is my friend."

Even more calamitous than the nationalistic isolation was the actual death toll which the war years took among the youthful Expressionists. Franz Marc and August Macke were killed in battle, Egon Schiele by the flu epidemic in the war's aftermath, and Wilhelm Lehmbruck died by his own hand.

It is a strange paradox that Beckmann embraced Expressionism only then, when the movement seemed to be doomed by the most unfavorable circumstances.

We cannot conjecture what Marc, Macke, Schiele, and Lehmbruck might have produced had they lived. Beckmann was spared, and his oeuvre after 1916 became not only ultramodern but, more importantly, qualitatively superior. The suffering, dying, and misery which he witnessed added an inner depth to his work. It was not until after 1917 that he developed into one of the giants of modern art.

When, after a pause of almost three years, he started to paint again, his fantasies had become lean, disciplined, reduced to utmost economy. A new note of irony, indeed of cynicism, rendered his style more inaccessible but much more interesting. His former rich, speedy, self-confident creativeness had given way to a tortured, compact constructivity. Convolutions and distortions of his figures marked them as Expressionistic in a narrow sense. His oil paintings from 1917 to 1922, painstakingly, almost painfully executed with thin washes of diluted paint, seem scared, frozen, crystallized. But there are at least three absolute masterpieces among them: *Christ and the Woman Taken in Adultery, The Night,* and *The Dream* (colorplates 3, 5, 6).

In 1918, Beckmann wrote this "Confession":

I don't weep, tears are hateful to me because they are a sign of slavery. I only think of objects. Piety? God? Beautiful, much abused words! I believe in both when I do my work. A painted hand, a grinning or weeping face—here is my credo: if I have felt something of life, it is expressed in these.

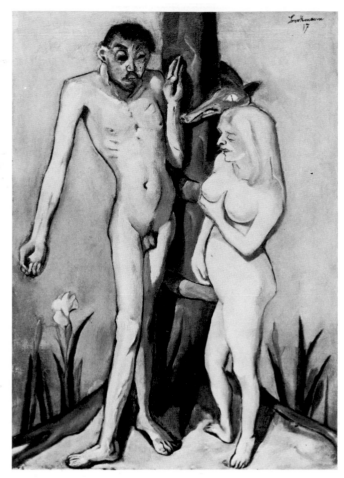

11. **Adam and Eve.** *1917. Oil on canvas, 31 3/4 × 22 1/2". Collection Dr. and Mrs. Stephan Lackner, Santa Barbara, California*

The war is now approaching its sad ending. We must participate in the entire misery which is about to come. Our hearts and our nerves we must abandon to the terrible cry of pain of the poor, deceived people.

It may really be senseless to love humanity, this assemblage of egotism (in which we have to include ourselves). I do so nevertheless. I love people with all their pettiness and banality, with their pigheadedness and cheap adaptability and their oh-so-rare heroism. In spite of all this, every human being on every day is a new event for me as if he had just descended from Orion.

Through four long years now we have gazed into the grimace of horror. Perhaps some of us have, thereby, gained a deeper understanding. We have got rid of much which was taken for granted. From a thoughtless imitation of the visible, from a weak archaism of empty decoration and from a falsely sentimental mysticism we may now proceed to a transcendental objectivity. This might emerge from a more profound love of nature and of people, such as we find it in the art of Mälesskircher, Grünewald and Bruegel, of Cézanne and Van Gogh.

This happens to be my crazy hope: to erect, some day, buildings together with my paintings. To build a tower in which men can cry out their fury and despair, all their poor optimism, joy and wild longings. A new church.

Perhaps time will help me.

If Beckmann's art around 1917 seems stark and drab and devoid of the saving grace of beauty, it is nevertheless deeply touching. The painter had lived through hell, he knew the suffering of Christ when the frail figure was taken down from the Cross. He understood the feeling of the degraded

12. **Costume Party.** 1920.
Oil on canvas, 71 1/2 × 36". Private collection

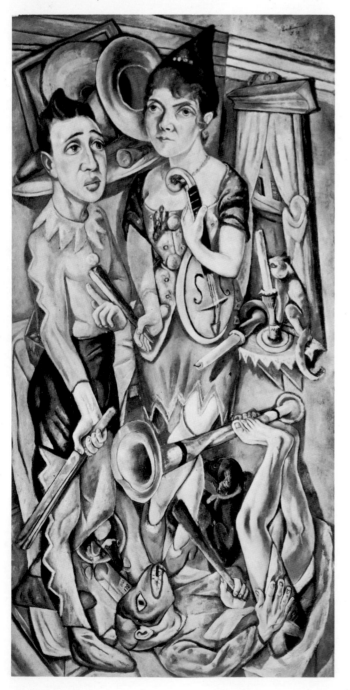

sinner and of the helpless victim of circumstance. Only through a new hardness of form, a steely geometry of composition, and an almost childlike simplification of design could he master his trauma and regain his power to formulate the visible world. These pictures do not present pity—they arouse it. By the very absence of any mild sentiment they force the spectator to add his own dash of pity.

Beckmann's world had become very narrow. He did not take up his married life again. He lived in Frankfurt with the family of Ugi Battenberg, a painter friend who let him use his studio. His reduced circumstances are reflected in the paintings of that period: almost none of them shows the horizon or the vastness of nature, which he had once loved and embraced so enthusiastically. The space of these compositions is no deeper than a packing crate. If there is a window in a back wall, it opens on nothing but the opaque night. Even an outdoor setting, such as that in *Christ and the Woman Taken in Adultery* (colorplate 3), is cut off by a fence of wooden boards. The big world is boarded up like an abandoned house whose master has departed.

Along with his thoroughly personal style and painterly virtuosity, Beckmann now acquired a pictorial vocabulary that would serve him until the end of his creative career. The musical curves of lutes and viols appear again and again until the completion of his last triptych. The noise-making instruments and funnel-shaped horns will half-mockingly accompany his *Lebenslied*, his strangely banalized and yet enigmatic song of life; the hurdy-gurdy will evoke the metropolitan folk art of a bitter *Threepenny Opera*. Senseless little lamps and candles will forever try to shed some light on the human drama. Repeatedly he will paint one lighted candle standing upright beside another that has fallen and is extinct, as he did in *The Night* (colorplate 5) of 1918–19. And forever his slippery fish will leave its natural habitat and deride our dry surroundings with its inappropriate humor. Sometimes this fish is phallic in shape and position; sometimes it reminds us that the early Christians, painting on the walls of their catacombs, used the fish as a symbol for Jesus. Beckmann's fish has no literal meaning; it seems to stand for something that we desire very eagerly and that keeps eluding us.

The most foreboding leitmotiv in Beckmann's sign language is the darkened sun. In the unfinished *Resurrection* of 1916–18 we find this blacked-out sun; in *The Descent from the Cross* (colorplate 4) of 1917 a reddish black disk leaves only a sad, carmine halo to shine on the desolate scene. And in his very last work, *The Argonauts* (colorplate 40), the sun is eclipsed again, but a luminous line of blinding gold flows out from its circumference, furnishing a ray of hope at the parting moment.

He started this train of symbolical thoughts in order to freight his objects with enough significance to last him

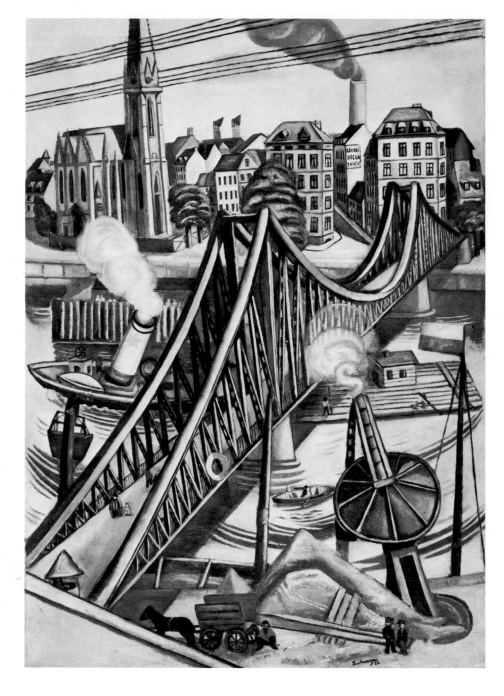

13. **The Iron Bridge.** *1922.*
Oil on canvas, 47 1/4 × 33 1/4".
Private collection

through his entire oeuvre, and during the years from 1916 to 1924 almost all of his pictographs were established.

The compositions of this period are of an admirable workmanship. Each movement has a countermovement, each decisive straight line has a near parallel at the other side of the canvas. If, in *The Dream* (colorplate 6), there is verdigris on the hurdy-gurdy, the leg stumps of the cripple have to be a poisonous green, too, for the sake of equilibrium. The round eye of the fish opposes and balances the round opening of the trumpet. Sometimes we feel that the procrustean bed of such compositions is not only motivated by man's inhumanity toward his fellow man, but also by Max Beckmann's harsh will to artistic excellence,

to external perfection through a visually satisfying pattern of lines and angles and planes. Beckmann's approximation of Cubist geometry springs from his resolve to rationalize the horrible vision of a ravaged world.

This is the time when the German critic Wilhelm Fraenger called him "the Hogarth of our epoch." In his graphic work that connection becomes even clearer. In the first postwar decade he produced a large number of drypoints, lithographs, and woodcuts, many of them in series with such titles as *Hell*, *Carnival*, and *City Night*, showing human creatures deformed by hunger, lust, disease, superpatriotic zeal, or utter loneliness. True, this was the style of the day. George Grosz and Otto Dix cultivated social

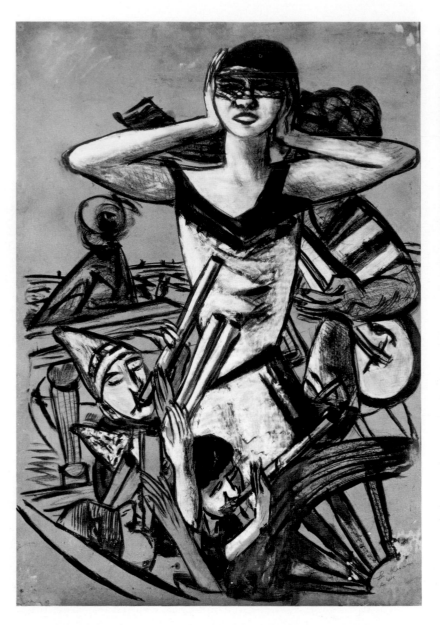

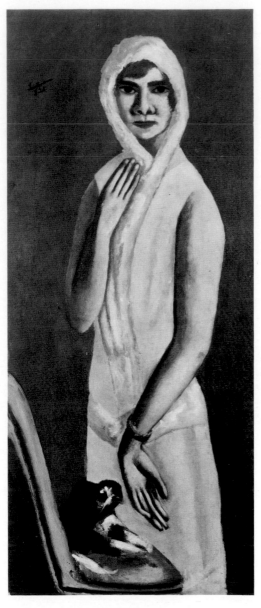

14. **Carnival in Naples.** *c. 1925. India ink with brush, black crayon, and chalk, 39 1/2 × 27 3/8". The Art Institute of Chicago. Gift of Tiffany and Margaret Blake*

15. **Portrait of Quappi.** *1925. Oil on canvas, 47 3/8 × 19 7/8". Private collection, New York*

consciousness in Germany; John Sloan in America, Georges Rouault in France, and Diego Rivera and José Clemente Orozco in Mexico had comparable tendencies.

In Beckmann's case this penchant for caricature lasted only until about 1924. He did not, however, become a cartoonist or a propagandist. He had sufficient reserves enabling him to pass on to larger vistas. His private hell, as an artist, finally turned out to be only a purgatory. But how was he to know while he had to traverse it?

This is how the writer Wilhelm Hausenstein saw him in 1924:

Beckmann, of proletarian build, a man of ponderous vigor, a workman, a weight lifter, has to carry his fate

heavily. For days and weeks he stays hidden behind his work, moaning under the load. When evening comes he throws down the burden from his broad shoulders. Through the dusk he wanders over the bridge across the Main River, lets objects and figures lose their contours, eats a hearty meal and finds himself in some bar where girls sit around and a jazz band plays angular rhythms. Or he lands in the railway station restaurant. There he sits with a black cigar, drinking champagne like a tycoon and looking straight ahead with blue eyes—a phantom. His hair is combed down into his forehead without a part. From time to time the large, pale, frozen face contracts into a nervous grimace. The mask twitches. This worker is in reality a gentleman with differentiated and

high-strung nerves. For the sake of mimicry he uses commonplace Berlin slang. In his relaxation he is already charging his battery again.

In 1924, the "seven lean years" of Beckmann's art were over. He was no longer attacked by nightmares. His work reflected this lessening of tension: backgrounds became more expansive and were lit by friendlier hues; he raised his eyes to a peaceful horizon. Correspondingly the foregrounds glowed with jewel-like flowers, glittering waves,

and attractive females. He had discovered for himself a new joie de vivre.

Germany had chosen a democratic middle road and was permitted to join the victorious powers in the League of Nations; there was a spirit of goodwill in the air, a cautious try at cooperation to make the planet a better place on which to live. Beckmann was willing to see the brighter side, too.

For him personally those were good years. Collectors, art dealers, and museums became more and more interested

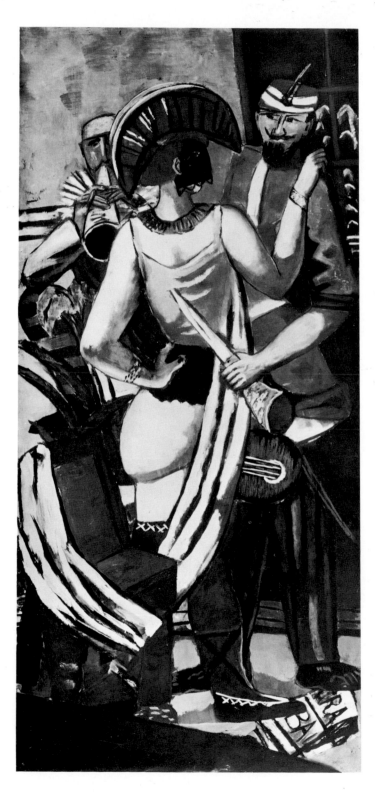

16. **Carnival in Paris.** *1930.*
Oil on canvas, 82 5/8 × 39 3/8".
Bayerische Staatsgemäldesammlungen, Munich.
Günther Franke Collection

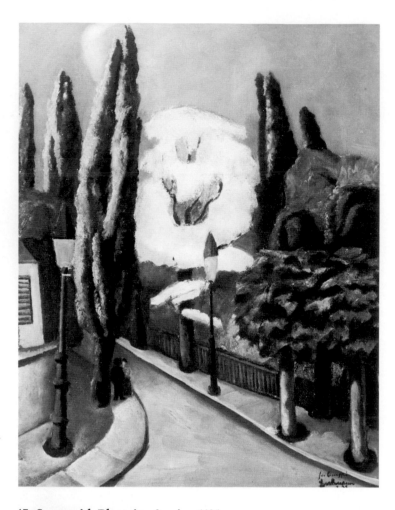

17. **Street with Blooming Acacias.** *1925.*
Oil on canvas, 21 3/4 × 17 3/4". Private collection, New York

drinking champagne. The artist himself makes a point of joining our enjoyment—he wants to "belong"; his own characteristic features frequently appear in the middle of elegant gatherings, often in the company of his lovely bride.

Circuses, masked balls, and cabarets offer the opportunity to paint bizarre beings, half man, half horse, or weirdly reptilian creatures. If these half-demonic shapes remind us of the demons of Hieronymus Bosch, Beckmann wants it understood that they are only disguised humans, and everyday bourgeois at that. The scene has become a big, jocular grotesquerie. Gone are the creatures of the dark which plagued Beckmann from 1917 to about 1923. After 1925 the cripples and grief-ridden widows and skeletons have retreated into invisible corners and attics. Are they still there?

They certainly are. They will emerge again after 1932, as part of this great artist's finest period: he will acknowledge all facets of the human condition, and in order to accommodate the enormous scope of his vision he will find it necessary to employ a tradition that combines several canvases—the triptych. But for the moment—it is 1925—he is a happily married professor of art in a congenial city, in the prime of manhood. The dark, doubtful, and gruesome side of the canvas of life has been turned to the wall.

Beckmann's paintings of the twenties comprise solid, well-defined, almost geometrical shapes, which are quite different from the loosely painted, temperamental, flickering figures of the other German Expressionists. They seem formally more closely related to Léger and earlier Paris Cubists.

Let us think back for a moment to the fateful sentence that Paul Cézanne wrote in 1904 to Émile Bernard: "Treat nature in terms of the cylinder, the sphere, the cone." When Cézanne viewed the results of his involuntary teachings in the products of the Cubist school, he was dismayed. So, in his youth, was Beckmann. But Cézanne's influence kept working on him, and he learned the lessons of clarification and stabilization. This *rigor vitae* appears in such methodically crystallized fantasies as *Trapeze* (1923), *The Barge* (1926; fig. 18), *Rugby Players* (1929; colorplate 16), and *The Skaters* (1932; fig. 19). Limbs are tubular, cheeks, female breasts, and skull caps are precise hemispheres. A pennant is spread out like a tin flag. Clouds are sharply contoured, like cigars or balloons; they float as dreamlike bodies through a clear, very evenly painted sky. Figures appear well-nourished now, often athletic. The colors are still iridescent, even luminous, but never to a degree that would dissolve the smooth surface of a body. All masses, even when airily suspended, have a well-defined weight; they are interrelated with the precision of a mobile. Often one fleeting moment is cut out of the sequence of a violent

in his paintings. In 1924, four leading art critics of Germany banded together to write a book on his work—one of the most substantial books on any living artist up to that time. In September 1925 he married his second wife, Mathilde von Kaulbach, whom he called Quappi, a charming woman of exceptional understanding who was to remain his devoted helpmate through prosperous as well as terrible times. Also in 1925, he became professor at the Städelsches Kunstinstitut in Frankfurt, a post he held until 1933. His Frankfurt years were peaceful without complacency, full of hard, self-critical work. His style became less self-consciously strict.

He developed an enormous appetite for life, a sensual joy which embraced the visible world. Sometimes we almost regret that the "spooks" have left him—he appears too exclusively concerned with the here-and-now. Of course, an artist has a perfect right to love the surface of things, but surface all too easily associates with superficiality. Yet we can thoroughly enjoy the worldly, epicurean scenes of dance halls and carnivals, of bathers and wealthy burghers

action and frozen into a permanent structure. The combination of rushing, pulsating life and headlong action with immutable monumentality is frequently quite stunning. Perhaps the artist wanted to show that an infinitesimal moment of time contains its share of eternity.

An artistic movement called *Neue Sachlichkeit* (New Objectivity) was influential in Germany about 1925. Most of its adherents are half-forgotten by now, but Beckmann had some sympathies for its approach; he preferred this method to that of the Expressionists. He always liked to

18. **The Barge.** *1926. Oil on canvas, 70 × 35″.*
Collection Mr. and Mrs. Richard L. Feigen, Bedford, New York

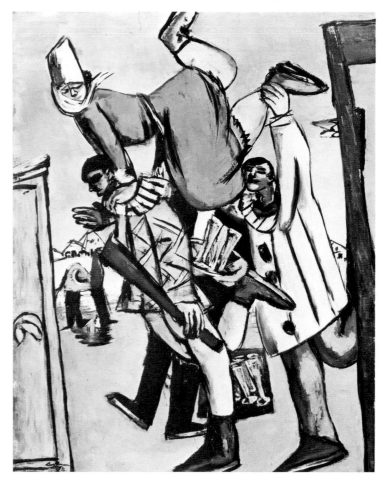

19. **The Skaters.** *1932. Oil on canvas, 50 1/2 × 38 1/2″.*
The Minneapolis Institute of Arts. Bequest of Putnam Dana McMillan

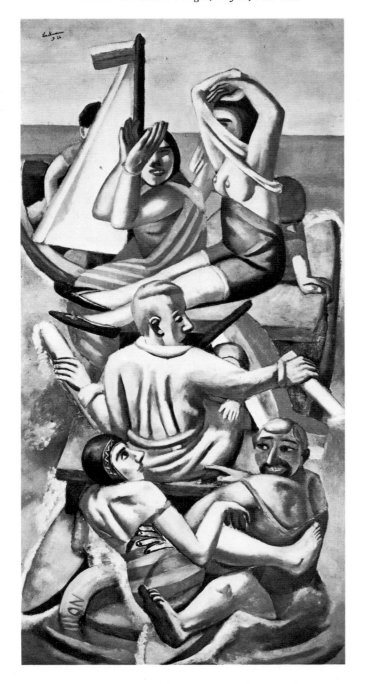

keep his distance, to appear calm and superior, and he disliked the romantic exaggeration, the professed oneness with nature, the *Schrei* and the *Oh Mensch!* theatrical posturing which was rampant in the early Expressionist plays, poems, and paintings. In the late twenties he seems to have forgotten that, only a few years earlier, he himself had been painting the cry of horror and the whimpering of tormented souls. When he drew or engraved a cabaret or a bar scene, before 1922, there were often dark, deeply lined faces with hollow eyes looking in reproachfully through the windows. Now these faces have evaporated like phantasmata. Beckmann has joined the merrymaking crowd on the inside; he wants to be an "insider."

Nineteen twenty-five to 1932 were his "seven fat years." His closest friends were of the upper crust, and some of his most ardent collectors were aristocrats (Lilly von Schnitzler, Baron von Simolin, Kati von Porada, and others). Museum directors, newspaper editors, successful writers, and wealthy businessmen gathered around him. The best circles of Frankfurt lionized him.

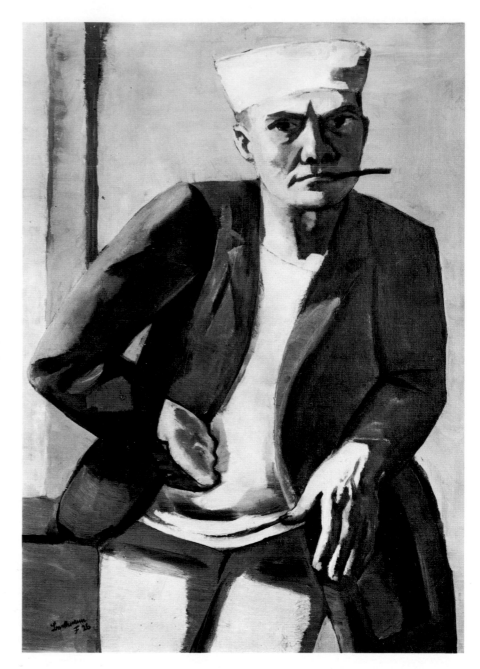

20. **Self-Portrait in Sailor Hat.** *1926.*
Oil on canvas, 39 3/8 × 27 1/2".
Collection Mr. and Mrs. Richard L. Feigen,
Bedford, New York

This feeling of civic importance is reflected in his *Self-Portrait in Tuxedo* of 1927 (colorplate 13). He was, perhaps, the only major artist of the time who felt at ease in a dinner jacket and who cared to present himself in this garb of the establishment. In that extremely important and felicitous picture, he occupies the exact center: he is in the middle of life, "nel mezzo del cammin di nostra vita." The forty-three-year-old bon vivant in a tuxedo wished to adapt himself to the mores of modern society.

Throughout his long career, Max Beckmann studied his variable image in ever-changing environments. He presented himself in carnival costume with a slapstick, or holding a horn or a saxophone; sometimes his attribute was a crystal ball or broken chains hung from his wrists. Beckmann painted, engraved, and drew his face grinning

or grieving, in fearsome self-doubt or philosophical detachment, in cynical or jocular mood, and with bravado or braggadocio. The self-assured, relaxed aspect of the 1927 *Self-Portrait* is quite exceptional in his oeuvre. It is a monument to the present moment between fulfillment and new promises—a monument to man at home in the world.

This *Self-Portrait* soon became Beckmann's most famous painting. The Nationalgalerie in Berlin bought it and hung it in a room exclusively devoted to his work in the Kronprinzenpalais. Indeed, this picture embodied certain qualities of the Weimar Republic: its sturdy, solid elegance; its successful bourgeois attitude; its sober trust in its own worth; and, above all, its will to hold the center. Germany prided itself in getting along with the Soviet Union as well as with the Western powers: a bridge between East and

West. The Republic tried to maintain an equilibrium between rightist and leftist forces. In a nation addicted to orderliness, the very symmetry of Beckmann's image made it one of the most successful German paintings of those years.

Who could have predicted that less than a decade later this canvas would be removed from the Berlin National-galerie and ridiculed as "degenerate art" by the Nazis?

DID A FAINT PREMONITION of his own future rootlessness reach the artist's subconscious in 1932, during his most prosperous and settled period? There is no obvious explanation for his sudden turn toward ancient mythology, and for the heroic, homeless figures that seem to breathe the free, blue, boundless atmosphere of *The Odyssey*. In May 1932 he began work on his first triptych, *Departure* (colorplate 21), with its antique travelers, and in 1933 he created a visionary watercolor of Odysseus bound to the mast of his ship while averting his hooded, tortured face from the sirens' song (fig. 22). This profile is clearly Beckmann's own. Many of his later works refer to scenes from Odysseus' peregrinations. Odysseus, the wanderer, became his persona. And very much later, in the diary of his exile years, he called himself "pauvre Odysseus." This was not idealistic, nineteenth-century classicism, but the sudden recognition of the mythical undertow in our existential journey.

Incidentally, there is a parallel development in Pablo

21. **Still Life with Cyclamen and Bronze Bust.** *1936.*
Oil on canvas, 31 1/2 × 20".
Collection Dr. and Mrs. Stephan Lackner,
Santa Barbara, California

Picasso's work of the 1930s. Picasso also turned from the contemporary scene toward classicism. When, in 1931, he etched illustrations for Ovid's *Metamorphoses* and in 1934 for Aristophanes' *Lysistrata*, his Mediterranean spirit was only confirmed. It is apparent that there was a neoclassical trend in European art at the time. For Beckmann it brought a vehement and radical change.

After completing his religious paintings of 1917, Beckmann had confined himself to the contemporary scene. For some fifteen years he treated only those themes that could be found in or around the modern cities of Central Europe, so that even his swimmers at the seashore looked like vacationing businessmen from Berlin. But from 1932 on he felt free to gaze back into the long ago and inward into a timeless world of myths and fables.

It may be too facile to assume that an artist's importance can be measured by the multiplicity of his themes or by the range of his subject matter. Still, Daumier would not appear quite as significant had he only painted judges and lawyers and passengers in third-class railroad cars; that he

22. **Odysseus and the Sirens.** *1933.*
Watercolor, 39 3/8 × 27 5/8".
Private collection, New York

was able to capture the grotesquely moving silhouette of Don Quixote makes us view him in a larger perspective. Of course Van Gogh could endow a pair of worn out boots on a wooden floor with compassion. Yet he also felt compelled to paint downtrodden prisoners trudging around a dark courtyard in a Dantesque circle of hopelessness. On the other hand, Degas, after painting Queen Semiramis rather unconvincingly in his youth, confined himself to strictly present-day Parisian scenes—and thereby relinquished his claim to the last greatness attainable by a painter.

It is ironic that precisely when Beckmann retreated from contemporary issues to contemplate wider vistas the politics of his day caught up with him in its nastiest form. In 1933 the Nazis came to power. Professor Beckmann lost his teaching job at the Frankfurt academy. He moved to Berlin; the metropolis seemed ·to offer more privacy and anonymity. Like so many people at the time, he thought that this crude regime could not last longer than a few months. Always an individualist, he hated all regimentation. He could not believe that true German culture—which he loved—would be swamped by the National Socialist "blood-and-soil" mystique.

A Beckmann exhibition had been scheduled for spring 1933 in the Erfurt museum, but it was not allowed to open. My brother and I had traveled there especially to see the show, and we were permitted to view the *verboten* paintings in the storeroom. I was so overwhelmed by the newly revealed mythical powers of Beckmann's *Man and Woman* that I bought the canvas immediately. My sense of outrage at the Nazi repression may have been one motive, but my youthful enthusiasm for this radiant work of art was the decisive factor. Beckmann told me, a little later in Berlin, that this purchase was the only sign of support he had received in that menacing situation, and that he would never forget my beau geste. Though I was twenty-six years his junior, we became close friends.

Soon all public and private galleries were forbidden to exhibit so-called "degenerate art." Undeterred, Beckmann continued working in his small but comfortable Berlin apartment. In 1934, rather late in life, he made his first sculpture, *Man in the Dark* (fig. 25), which actually revels in three-dimensionality; as a painting, this idea simply would not have worked. Beckmann executed only seven other sculptures before his death in 1950, including the bronze *Self-Portrait* of 1936 (fig. 26).

The Nazis were busily reorganizing literature, theater, art, and music by centralizing all artistic endeavors in the Reichskulturkammer where creative activities were strictly channeled and easily supervised. Jewish, pacifist, and socialist artists were the first to be rigorously persecuted, but Beckmann belonged to none of these groups, so he was left to his own devices. That same year, 1934, his

23. **Catfish.** *1933.*
Oil on canvas, 53 1/8 × 45 1/4".
Musée National d'Art Moderne, Paris

24. **Snake King and Beetle Bride.** *1933.*
Watercolor, 24 × 19".
Collection Bernhard and Cola Heiden,
Bloomington, Indiana

fiftieth birthday passed without a single mention in the German press. He was denied membership in the official painters guild, the Reichskammer der bildenden Künste. He was a strictly private citizen and almost glad to be a forgotten man.

Then, in 1935, a rather innocent event in faraway New York drew attention to him again. Mrs. John D. Rockefeller, Jr., gave his *Family Picture* of 1920 (fig. 27) to The Museum of Modern Art. As *Time* magazine described it: ". . . a family of grotesque, square-headed Germans . . . The Nazi pundits suddenly got hopping mad. Wailed they: 'Does Mrs. Rockefeller take us for such stupids [as the painting portrays], or does she take New Yorkers for such stupids that she hangs this up as a little bit of Germany?'" After this publicity Beckmann's circumstances worsened rapidly.

It so happened that many of the art dealers, critics, publishers, and collectors in Germany were Jewish; Paul Cassirer, J. B. Neumann, Alfred Flechtheim, and Curt Valentin, for example, had all been Beckmann's enthusiastic champions. But there were, of course, many "Aryan" supporters of Beckmann's art, such as Julius Meier-Graefe, Reinhard Piper, and Günther Franke. Now the "non-Ary-

an" cognoscenti were suddenly declared to be subhuman criminals plotting to corrupt and weaken the innocent, heroic soul of the German race. The Jewish art critics, museum directors, and art dealers, deprived of their livelihood, fled Germany; some of those who remained disappeared later in concentration camps. The exodus left Beckmann ever more isolated.

German nationalism had a traditional antipathy toward modern art. Kaiser Wilhelm II was quite vocal against the *Rinnsteinkunst* (gutter art) of the German Impressionists (such as Max Liebermann) and against the Naturalism of Wedekind and Hauptmann in literature. His dictum: "Die ganze Richtung passt mir nicht" (This whole movement does not please me) was widely satirized during his reign. But when Hitler came to power, he did not tolerate any witticism. Having been an unsuccessful painter of innocuous little watercolors himself, he was convinced that he knew all about art. For a man of stormy temper and grandiose visions, his taste was strangely petit bourgeois, tame, and reactionary. Mussolini, in contrast, had a strong taste for Futurist and experimental art. To Hitler, the exciting stirrings of new art movements were simply fever symp-

toms: the Jews had injected some poison into the *Volkskörper* (the organism of the German people), and he had to help this "folk body" back to glorious health. The paintings he usually liked were nude blondes, heroic soldiers, peasants weaving and digging with archaic tools, and meticulously detailed landscapes. A monumental exhibition hall was built in Munich and filled with this kind of kitsch to show Germany and the world what, for the duration of the Thousand Years Reich, was to be considered German art.

On July 18, 1937, Hitler opened his Haus der Deutschen Kunst in Munich with a vehement speech against all modern art:

Cubism, Dadaism, Futurism, Impressionism, etc. have nothing to do with our German people. . . . There are indeed certain men whose eyes show them things differently from what they are. They see the living figures of our people only as degenerate cretins, they see or "experience" meadows as blue, skies as green, clouds as sulfuric yellow. . . . The Reich's Ministry of the Interior would have to decide if at least the further hereditary propagation of these horrible visual disturbances should be

25. **Man in the Dark**. *1934. Bronze, height 22 3/4".*
Formerly Catherine Viviano Gallery, New York

26. **Self-Portrait**. *1936. Bronze, height 14".*
Formerly Catherine Viviano Gallery, New York

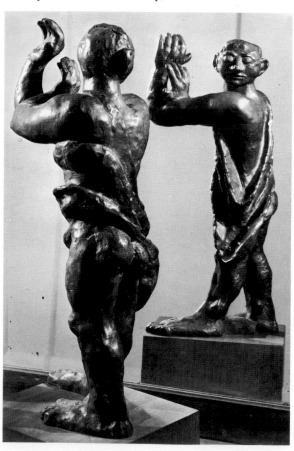

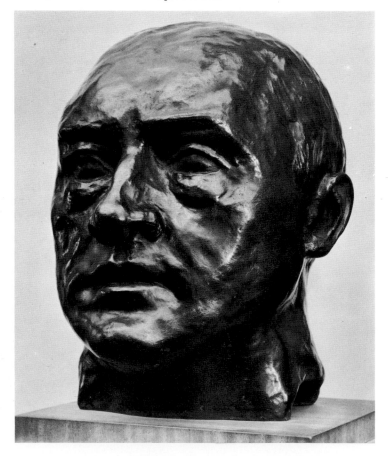

Amsterdam where, in 1937, he had found an old tobacco storeroom large enough to serve as a studio for the enormous new visions he wanted to realize. He succeeded in getting his paintings and some belongings out of Berlin, and he set to work at a furious pace. One of the first paintings he completed in Amsterdam was *The Liberated One* (*Der Befreite*). In this self-portrait a broken chain hangs from the artist's wrists, a dark, grilled window is seen in the background, and a luminous, azure glimmer plays on his face, signaling an intense, almost fierce hope.

"A refugee is someone who has lost everything but his accent." Though this wry joke was not literally true in Beckmann's case, he had difficulty adjusting to his new expatriate existence. His appearance was undeniably Germanic, with his slow-moving, almost gigantic frame, his light blue, penetrating eyes, and his still dark blond hair. Many of the French felt uncomfortable and even distrustful with Germans, be they Nazis or refugees. The Swiss and the Dutch were appalled by the stream of German emi-grants, and there were spy scares and fears about job competition. Papers were never quite in order, and licenses had to be obtained for almost every activity. And, altogether, art was not in urgent demand. Nevertheless, Beckmann's friends succeeded in arranging exhibitions for him, although sales were extremely infrequent.

In 1938 he was well represented at the "Exhibition of Twentieth Century German Art" in London at the New Burlington Galleries. Here 269 paintings and sculptures by German Expressionists, Surrealists, and abstract artists were assembled to counteract the propaganda effect of the Nazis' vicious "Degenerate Art" exhibition. The purpose was only partly fulfilled, for the reticent British were taken aback by the unaccustomed vehemence of what was, to them, unfamiliar art. The whole enterprise seemed exotic and quixotic. *The Manchester Guardian*, for instance, wrote on July 7, 1938: "The centrepiece of the main gallery is a huge triptych, *Temptation*, by Max Beckmann, big in conception, arbitrary in drawing, full of wild overstatements,

30. **Reclining Woman.** *Before 1937. Oil on canvas. Whereabouts unknown*

31. **Portrait of a Girl** (*unfinished*). *Before 1939.*
Oil and pastel, 36 × 29". Collection Dr. and Mrs.
Stephan Lackner, Santa Barbara, California

but none the less powerful and gripping. . . . It is a disturbing show."

For the first time in his life, Beckmann gave a formal public lecture. When he strolled to the dais of the exhibition hall, he looked like a bear lumbering out of his cave and shaking off the cobwebs of hibernation. That speech has become justly famous, its most frequently quoted sentence: "If you wish to get hold of the invisible, you must penetrate as deeply as possible into the visible." Beckmann actually enjoyed the brief flare-up of publicity, the meetings with leftist intellectuals and impressive aristocrats, and the free and civilized atmosphere of London.

And then he went back to his abandoned tobacco storeroom in Amsterdam and painted and painted.

What was Beckmann's technique, his method? He always worked in seclusion and almost never showed his unfinished products. His diary registers long hours of exhausting work which sometimes extended over months on one painting, yet it hardly clarifies what the struggle was about. There is an unfinished *Portrait of a Girl* which offers a fascinating glimpse of Beckmann's art in statu nascendi (fig. 31). The decisive, quick, sure outlines with which he always started to organize a new canvas are there. His black paint was mixed with paint thinner and liquified in varying degrees, so that he could sketch with speed and subtlety, producing the effect of an India ink drawing. In its

32. *First stage of* **Two Spanish Ladies,**
with Beckmann's profile in the mirror. Before 1939.

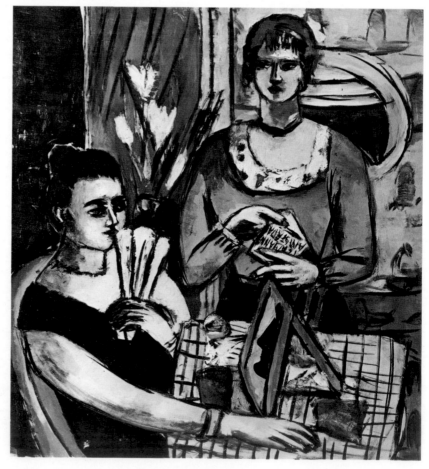

airiness and unspoiled spontaneity, it is an altogether lovable creation, and one hardly regrets that it is unfinished.

Beckmann's wife Quappi has described how he often used pastels to try out a color scheme before he attacked the composition with oils. He then carefully wiped the pastel colors off the canvas so as to keep his oil paint pure.

If he later decided to make major changes, he sometimes laid the painting on the floor, soaked the dried oil paint with a solvent overnight and removed the paint in the morning, thus clearing a whole area of his canvas in order to start anew. He did not like overpainting, and his desire to keep the pigments flat, clean, and manageable gave an air of spontaneous decision to his brushstrokes. His temperament always regained control.

Occasionally he went to great lengths to correct or to re-create a work. Photographs of early stages of *The King* and of *Self-Portrait with Horn* (figs. 33, 34) show how much thought and deliberation went into the painting process before the artist was satisfied (compare fig. 34 with colorplate 30).

The exiled Beckmann did not become either a gloomy hermit or an ascetic pessimist. His love for the visible was too strong. Numerous landscapes from those years indicate that the painter did not relinquish his passionate involvement with nature. The Dutch seacoast in all its cool, chaste loveliness, with varicolored cloud formations and unending light variations, became a great stimulant. Two short trips to southern France proved even more exciting to the artist. He never painted on location; he did not even possess an outdoor easel. He made pencil sketches and more elaborate charcoal drawings, but he took pains to hide this activity. From sketches and from his accumulated memories he later composed his oils. The cityscape of Paris was, for a while, his great love. His paintings of the Place de la Concorde, the Sacré-Coeur, and the Bois de Boulogne are among his happiest pictures.

As the Nazi menace grew ever more formidable, Beckmann's old wish to come to the New World became more urgent. The attraction was great: in summer 1939 his *Temptation* (colorplate 24) won first prize at the Golden Gate International Exposition in San Francisco; the courageous Curt Valentin did quite well with the German Expressionists in his New York gallery; and The Art Institute of Chicago offered Beckmann a teaching post. In spite of all this, it was impossible for Max and Quappi Beckmann to obtain American visas. In May 1940 Hitler's blitzkrieg overran Holland; Beckmann had missed the boat.

When the German armies approached Amsterdam, Beckmann burned his diaries of 1925 to 1940 for fear that they might compromise old friends. His wife saved only a few important pages. However, his complete diaries

33. *First stage of* **The King.** *1934.*
Oil on canvas, 53 1/4 × 39 1/2". (For final version, see colorplate 27)

34. *First stage of* **Self-Portrait with Horn.** *Before 1938.*
(For final version, see colorplate 30)

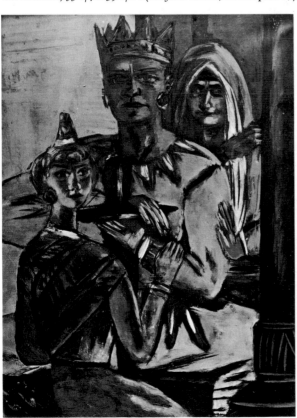

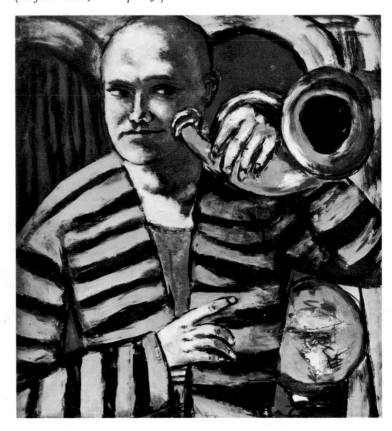

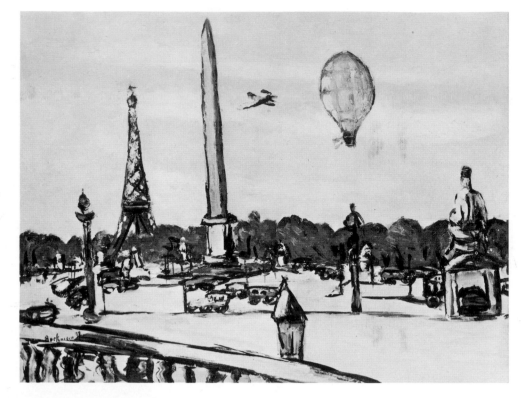

35. **Place de la Concorde, Paris, with Balloon.** *1939. Oil on canvas, 18 1/2 × 24″. Collection Mr. and Mrs. Alexander J. Oppenheimer, San Antonio, Texas*

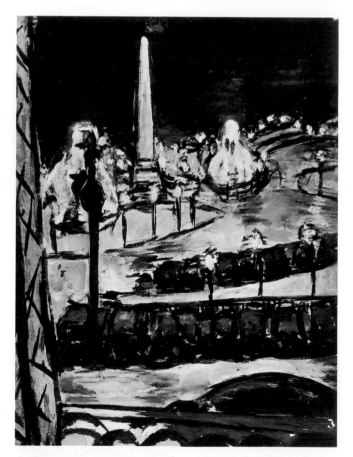

36. **Place de la Concorde by Night.** *1939. Oil on canvas, 24 × 18 1/4″. Galerie Rudolf Hoffmann, Hamburg*

from September 1940 to his death in December 1950 have been preserved. They give a vivid account of his outer and inner life. The blocking-out of a freshly conceived triptych is registered as conscientiously as a hasenpfeffer dinner cooked by Quappi, or a pleasant evening in a bar. Pains in his chest are mentioned as frequently as bombings and wild war rumors. He describes his bicycle trips through the countryside, or he ponders the thoughts of "my poor Vincent" when he reads Van Gogh's letters. Sometimes he is gripped by terrible fears for the fate of Europe and for his own future. Sudden illuminations generate speculations about the task of the artist; God needs him to realize and shape the eternal, indestructible ego—which is always the same through all phenomenological metamorphoses. Such far-reaching fantasies provide the courage to go on with his almost unseen and unappreciated work.

The greatest stroke of good fortune in the general misery of those years was the renewed contact with his son, Peter. Since the divorce from his first wife, Beckmann had seen his young son only on rare occasions. Now, in January 1941, Peter visited his exiled father in Amsterdam. This was possible because Peter had become a physician in the German air force. Father and son developed a warm and lasting friendship. To help his father, Peter smuggled many of his canvases back into Germany where faithful old friends bought them. In August 1942 he accomplished the daring exploit of driving into occupied Amsterdam

with a Luftwaffe truck and loading it with the huge *Perseus* triptych and seven smaller paintings. On the way back, at the German frontier, he was stopped by soldiers who inspected the "degenerate" pictures with utter distrust. Peter made light of it: "I've painted these myself, as a joke. Don't you see, it says Beckmann right here." The border guards let him pass, and Peter transported the paintings to Berlin where Günther Franke, one of Beckmann's prewar art dealers, acquired the *Perseus*. It now has an honored place in the Folkwang Museum of Essen—a monument to the spirit of resistance inside National-Socialist Germany.

A conspiratorial underground atmosphere is evoked by some pictures of those years. Their inventiveness is not marred by association with the terror of World War II. Whereas World War I had interrupted Beckmann's painterly development and thrown him into a new artistic orbit, the war years of 1940 to 1945 brought no such change. In 1932 he had found the rich vein of his free, allegorical style, and living dangerously could not prevent him from working this lode.

All through the diary of the war years there is as much hope for an *invasie* (Dutch for invasion) as the risk of a Gestapo inspection would permit. On May 5, 1945, Beckmann records that the "green police are still driving about with machine guns," but on May 8 he says: "The British are now arriving in great masses with tanks and lorries, the populace sitting on top rejoicing." May 9: "Saw the green police captured, transported off in lorries. . . . In the evening we saw terrible sights, one could hardly believe it." He does not elaborate. On May 11 he notes philosophically: "We see the Canadians with the Dutch girls who have simply switched from Germans to Canadians. That's all. There is still no food." The lack of cigars and alcohol was also disagreeable, but the worst was a shortage of canvas. Quappi sacrificed two of their three bedsheets for Max to paint on.

As soon as communications with the outside world became somewhat normal, Beckmann shipped thirteen new pictures to New York. They reached Curt Valentin's gallery on April 4, 1946, and on May 4 Valentin could telegraph to Beckmann that ten paintings had already been sold from his very first exhibition of new paintings since 1939! Beckmann was jubilant. His diary is full of half-ironic, half-enthusiastic remarks on the significance of worldly fame. "The old cadaver of which the radiant pilot has been cheated is now being tickled with laurels—."

He never wavered in his resolve to travel to America, even when he received the most urgent and flattering offers from Germany. July 9, 1946, was a red-letter day as far as German "war reparations" were concerned: "Wild shindig down there in Munich, eighty-one pictures in the Stuck

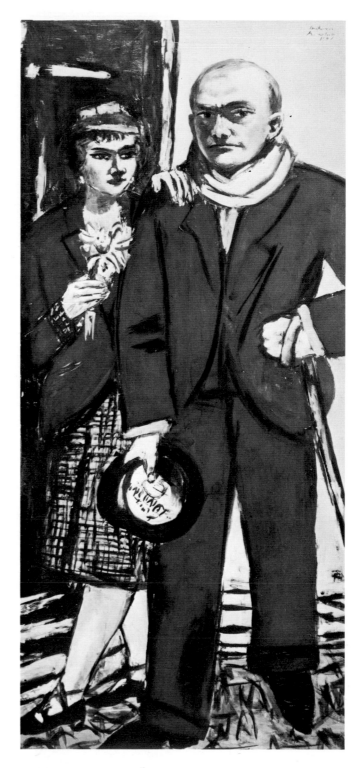

37. Double Portrait of Max and Quappi Beckmann. *1941.*
Oil on canvas, 76 3/8 × 35".
Stedelijk Museum, Amsterdam

Palace with four hundred persons present, among whom Peter and Minna, and an opening speech by Hausenstein. Crazily dreamlike. Well, invisible man, you are becoming disagreeably visible, and it is high time to invent a new disappearing powder."

A few retrospective remarks about the relationship of the American art world to Beckmann may be in order. J. B. Neumann had pioneered German Expressionism in New York in the twenties, and there were interesting affinities between some younger American artists and their German counterparts, although the School of Paris held a quasi-monopoly. In March 1931, New York's Museum of Modern Art opened a large exhibition, "German Painting and Sculpture," of exactly those artists who were later branded as "degenerates." There were eight Beckmanns in the show. The introduction that Alfred H. Barr, Jr., wrote at that early date was perspicacious and enthusiastic: "Beckmann's originality of invention, his power in realizing his ideas, his fresh strong color, and the formidable weight of his personality, make him one of the most important living European artists. . . . Whether the genuine greatness of his personality will be realized in his paintings so that he will take his place among the half dozen foremost modern artists is a question which the next few years should answer."

Seven years later, reviewing Beckmann's new show at Curt Valentin's gallery, Helen Appleton Read referred back to this query (*Magazine of Art*, February 1938): "The answer to Mr. Barr's question should be, 'Yes, Max Beckmann can be said to take his place beside those half dozen artists who are accorded international recognition.' Today he has become so sure a master of his medium that the idea is conveyed without calling attention to the means. . . . The symbolism, although obscure, is imaginative and deeply moving."

Friendly voices calling across the Atlantic became a chorus eight years later, after the Valentin exhibition, and

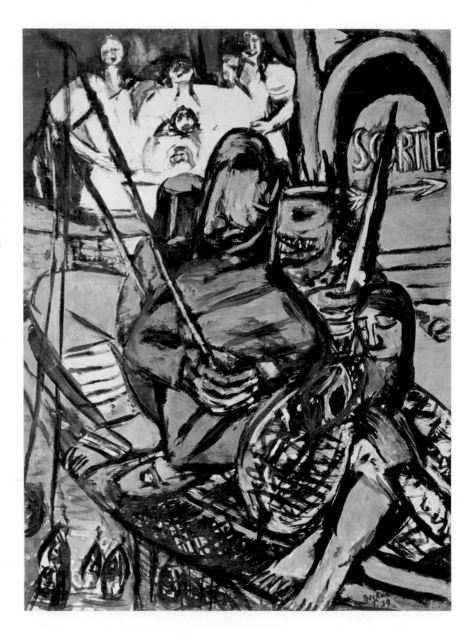

38. **Demons Fishing for Souls.** *1939.*
Oil on canvas, 31 1/2 × 23".
Collection Dr. and Mrs. Stephan Lackner,
Santa Barbara, California

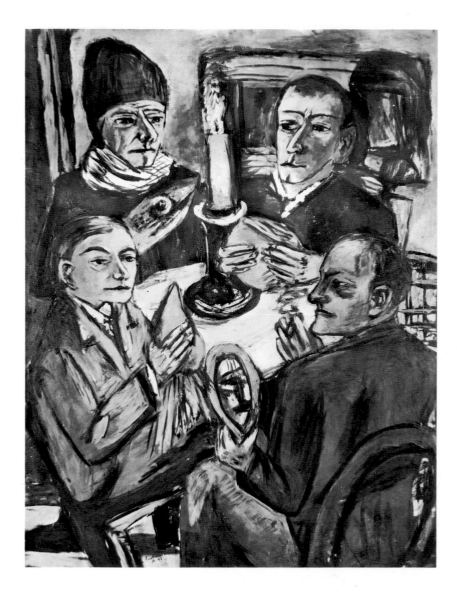

39. **Four Men Around a Table.** *1943.*
Oil on canvas, 58 3/8 × 45 1/2".
Washington University Gallery of Art,
St. Louis

40. **Still Life with Skulls.**
1945. Oil on canvas,
21 3/4 × 35".
Museum of Fine Arts,
Boston. Gift of Mrs. Lois Orswell

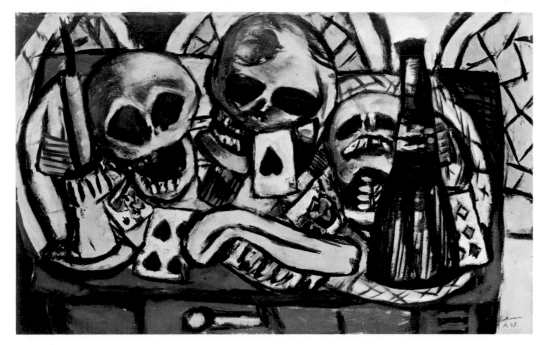

41. *Translation of an excerpt of a letter from Beckmann to the author, 1945:*

Amsterdam Rokin 85 27 August 45

Dear Stephan Lackner (Quinientosstreet)
Oh—well, there you are living, amazing to hear from you and California. The world is pretty much destroyed, but the specters climb out of their caves and pretend to become again normal and customary humans who ask each other's pardon instead of eating each other up or sucking one another's blood. The entertaining madness of war evaporates and distinguished boredom sits down again on the dignified old overstuffed chairs. Incipit "novo Canto" No. 2—

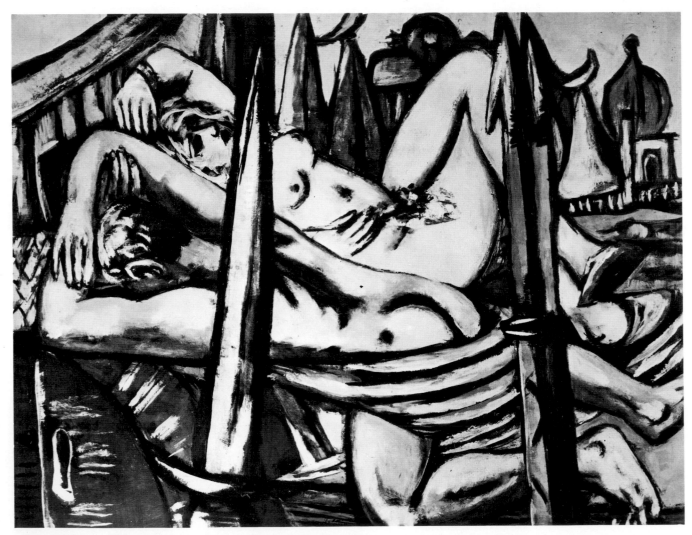

42. **City of Brass.** *1944. Oil on canvas, 45 1/4 × 59". Saarland-Museum, Saarbrücken*

43. Windmill. *1946.*
Oil on canvas, 51 1/8 × 29 1/2".
Collection Morton D. May, St. Louis

that he would indeed be welcome in America. He accepted the invitation of Washington University in St. Louis.

Beckmann continued to paint until his belongings were packed for the journey to America; one canvas, *Flower Corso in Nice*, had to be crated while still wet. On August 27, 1947, the Beckmanns finally embarked for New York.

AMERICA HAD A TREMENDOUS IMPACT on the artist. The three years that remained to him were filled with excitement and wonder. The very freshness of the country forced the old European to view it against a mythical background. His first glimpse of New York reveals this perspective: "Arrived at dawn. Veiled giants stood sleepily in the wet fog on Manhattan." And the next day: "Yes, New York is really grandiose, only it smells of burnt fat like the roasted pieces of slain enemies among savages. But, nevertheless—crazy, crazy, crazy. Babylon is a kindergarten

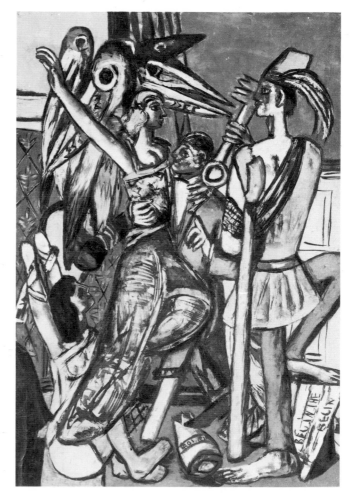

44. Begin the Beguine. *1946. Oil on canvas,*
69 5/8 × 47 3/8". The University of Michigan
Museum of Art, Ann Arbor

to the erstwhile underground painter they seemed magnetically attractive. *The New York Times* wrote on April 28, 1946: "It is indeed good to have Max Beckmann restored to us, after the agonizing interlude of Hitler's destructive madness." And in *The Herald Tribune* of the same date: "There is tremendous impact to Beckmann's work, the vigorous patterning of the expressionist and his color resounding in the visitor's mind long after he has left the exhibition." *Time* said on May 6, 1946: "His fiery heavens, icy hells, and bestial men showed why he is called Germany's greatest living artist. He had splashed on colors with the lavish hand of a man who wakes up to find a rainbow in his pocket."

When two teaching positions were offered to him, he felt

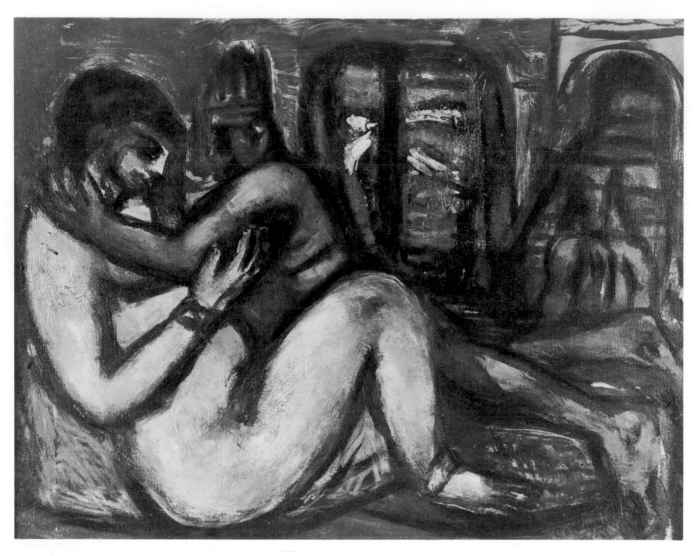

45. **Leda.** *1948. Oil on canvas, 16 × 20 3/4″. Collection Mr. and Mrs. George Rickey, East Chatham, New York*

compared to this, and the Tower of Babel is here trans-formed into the mass-erection of a gigantic (and perhaps senseless) will. Therefore, sympathetic to me."

Wherever he travels, he finds these distant overtones of myth and fantasy. In St. Louis he notes: "Funny that in all cities I always hear the lions roar." When he reaches the Pacific Ocean in Carmel, he writes: "Observed two giant birds which circled around my head with lazy wing strokes like plesiosaurs. Having fed in the swamps, they flew out over the sea. Gray sky and sand. Beautiful and ancient." The sea lions gave him "an eerie and grand impression, as one of them, like a mythological mammoth, cut diagonal-ly into the sky. Freedom and eternity over the horizon." In Nevada he ponders some fossil footprints of giants pre-served in sandstone. "Very interesting, giants really seem to have existed." The rock formations of the "Garden of the Gods" in Colorado had a ghostly attraction for him. "The red-rock giant specters haven't grabbed us, after all." These

archaistic double takes found their expression in some drawings depicting the Nibelungen saga, the fight of the queens, the "irrational greed and tragedy." Strange to think that a tourist attraction in America should cause a painter to study the *Nibelungenlied.* The prehistoric giants, sea lions, cormorants, and mythified skyscrapers described in Beckmann's diaries were all utilized in his later artistic production.

That is not to say that he neglected the contemporary scene. His American portraits reveal a deep fondness for modern man. The nervous excitement, the clarity, and al-most stenographic abbreviation of these statements belong definitely to the middle of the twentieth century. He was fortunate enough to find some wonderful new friends. Morton D. May of St. Louis recollected the procedure of having his portrait painted by Beckmann: "He spent two weeks getting to know me before he even made a sketch. Then there were two sittings of not more than a half hour

each. Before he started to paint, he had pulled out my history. He tried to paint much more than what's on the surface of the canvas" (fig. 49).

Perry T. Rathbone, then director of the City Art Museum of St. Louis, tried perhaps more than anyone else to make Beckmann feel at home in the United States. He organized a large Beckmann retrospective exhibition in 1948, which was shown in St. Louis, Los Angeles, Detroit, Baltimore, and Minneapolis. Beckmann portrayed Rathbone as a clear-eyed, relaxed, and energetic American intellectual (fig. 50).

No small part of Beckmann's relationship with Americans was provided by his teaching activities. When he approached his first teaching job at Washington University, he was highly nervous. But, characteristically, the visual impression of his class reconciled him very fast: "A really lovely picture, the good-looking girls and boys." Soon he developed a deeper concern for his pupils. He believed two or three of them were gifted; he shared their joys when they received scholarships or prizes. About their economic situation he said sorrowfully: "Yes, it is difficult to paint and to live." He followed their progress over the next few years with pride.

He must have been a good teacher, for he was engaged for summer courses at the University of Colorado in Boulder and at Mills College in Oakland, California. He finally received a permanent position at The Brooklyn Museum Art School in New York.

One of his former students at Mills College, Elizabeth M. Polley, wrote about Beckmann's way of teaching in

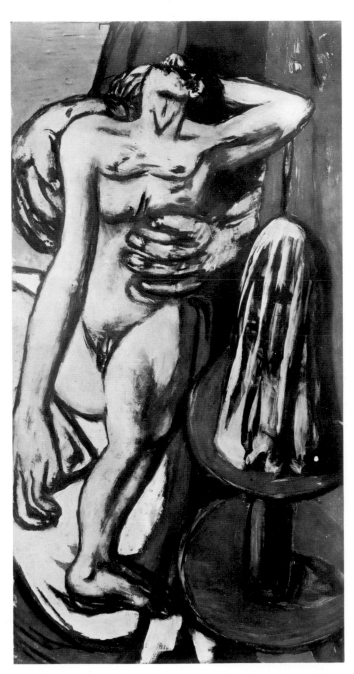

46. **Dream of a Sculptor.** *1947.*
Oil on canvas, 53 × 27 1/2".
Collection Stanley Joseph Seeger, Jr.,
Frenchtown, New Jersey

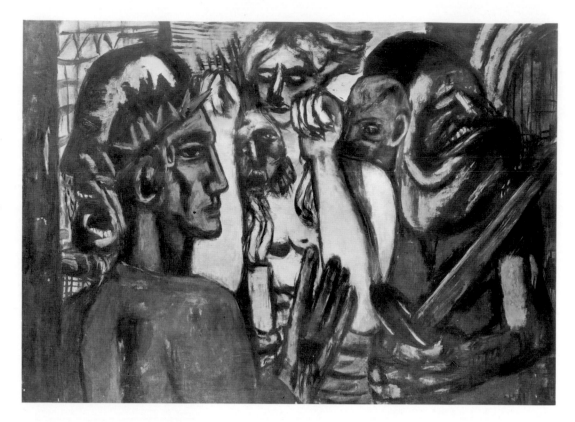

47. **Christ in Limbo.** *1948.*
Oil on canvas,
31 × 42 3/4".
Private collection, New York

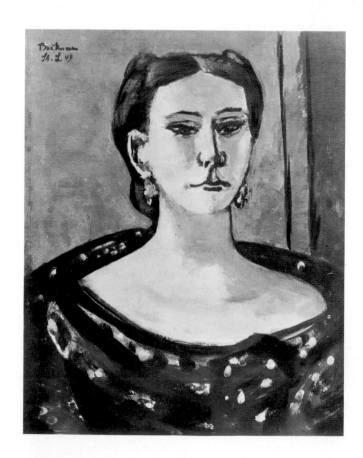

48. **Portrait of Louise V. Pulitzer.** *1949.*
Oil on canvas, 25 1/4 × 20".
Collection Joseph Pulitzer, Jr., St. Louis

the *Vallejo Times-Herald* of July 31, 1955; her reminiscences merit reprinting:

At a student concourse and "fat chewing" session (at which sessions I sometimes think that painters learn more than in a regular classroom!) Beckmann stated rather positively in answer to a question: "*Art* cannot be taught," then added in his deceptively mild mannered way, "but—*the way to art* can be taught."

"Method?" he continued, rubbing his unexpectedly blond hair from his forehead. "As you see, I have no method. There is no recipe. What I say and direct is different for every individual student. Each one is a special case."

Language was somewhat of a barrier for the ruggedly built German, and his wife stood by to act as interpreter for his more lengthy conversations—but he had no difficulty putting his point of "work a lot—simplify—use color, lots of color—make the painting more personal—" across to his students and followers. He was impatient with the faltering beginner, and simply ignored those students who clung tenaciously to the extremely academic and the extremely abstract.

"I am not particularly concerned with symbolism," he once said. "I do not talk to myself of symbolism at all. I am concerned only with the architecture of the painting; the subject is absolutely personal. What I do,

and help my students to do, is to bring the image to the surface."

A talk that Beckmann gave in St. Louis in June 1950 has fortunately been preserved; it presents the whole man and his artistic philosophy. (The translation is by Jane Sabersky.)

Friends have asked me to say something during this reunion about Art. Should one embark again on the discussion of this old theme which never arrives at a satisfactory conclusion because everyone can speak only for himself? Particularly the artist who, after all, can never escape his calling? Isn't it much nicer to go for a walk and experience the new, young dream of spring instead of getting entangled in dry theories or arriving at inconclusive results?

Indulge in your subconscious, or intoxicate yourself with wine, for all I care, love the dance, love joy and melancholy, and even death! Yes, also death—as the final transition to the Great Unknown. But above all you should love, love, and love! Do not forget that every man, every tree and every flower is an individual worth thorough study and portrayal.

And when you ask me again, how should I make this study and portrayal, I can only tell you again that in Art everything is a matter of discrimination, address, and sensibility, regardless of whether it is modern or not. Ever important is keen awareness and uncompromising self-criticism. The work must emanate truth. Truth through love of nature and iron self-discipline.

If you really have something to say, it will always be evident; therefore do not shy away from tears, from despair and the torment of hard work, for in spite of it all, there is no deeper satisfaction than to have accomplished something good, and therefore it is worth your while to sweat a bit.

This is all that might be said about painting. I do be-

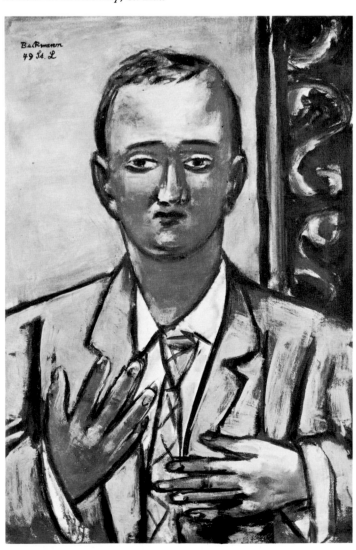

49. **Portrait of Morton D. May.** *1949.*
Oil on canvas, 30 × 20".
Collection Morton D. May, St. Louis

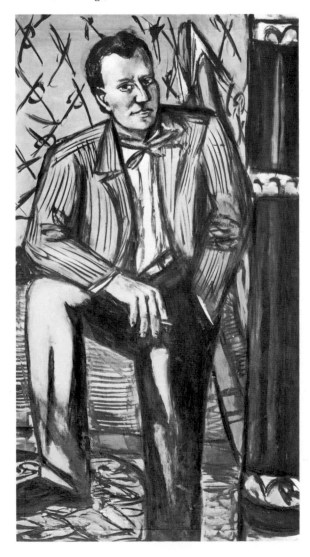

50. **Portrait of Perry Rathbone.** *1948. Oil on canvas, 64 × 34 1/2". Collection Mr. and Mrs. Perry T. Rathbone, Cambridge, Massachusetts*

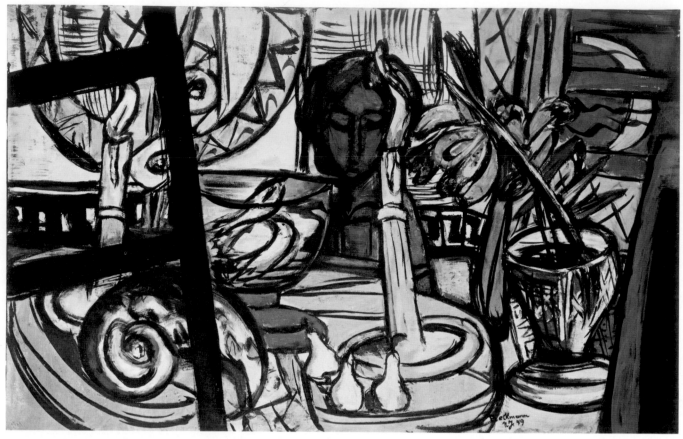

51. **Still Life with Candles.** *1949. Oil on canvas, 35 × 55 7/8″. The Museum of Modern Art, New York*

52. **Perseus' Last Duty.** *1949. Oil on canvas, 35 × 56″. Collection Stanley Joseph Seeger, Jr., Frenchtown, New Jersey*

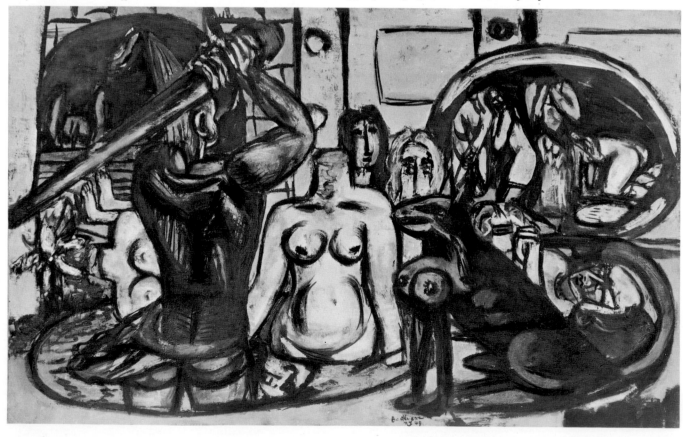

lieve, however, that this very problem applies to all the arts and sciences. Purposely I have avoided commenting on the art theories as I am a sworn enemy of putting art in categories. Personally, I think it is high time to put an end to all "Isms," and to leave to the individual the decision whether a picture is beautiful, bad, or boring. Not with your ears shall you see but with your eyes.

Greatness can be achieved in every form of art; it depends alone on the fertile imagination of the individual to discover this. Therefore I say not only to the artist but also to the beholder: if you love nature with all your heart, new and unimaginable things in Art will occur to you. Because Art is nothing but the transfiguration of nature.

Manhattan's skyscrapers nodded reflectively to my thoughts—some of them reared themselves even prouder than before. Right, they said, right—we too have become nature, Man-made—but grown above man—and slowly they have vanished in the warm gray mist of a spring evening.

Art, with religion and the sciences, has always supported and liberated man on his path. Art resolves through Form the many paradoxes of life, and sometimes permits us to glimpse behind the dark curtain which hides those spaces unknown and where one day we shall be unified.

Professor Fred Neumeyer, who was responsible for Beckmann's teaching engagement at Mills College, took a realistic snapshot of the painter on July 20, 1950: "Evening with Beckmann. He has only three teeth in the middle, and his descending, rather rough features give him the air of a sad bulldog. His speech, too, sounds growling, laconic, somewhat vulgar. Under this shell one feels concentration, fatigue, impatience: an egocentric sensitivity. His eyes are wide-awake and alive. Strangely enough, in spite of his reserve, he doesn't appear cold, but rather sluggish and good-natured. . . . An immensely complex man." This unflattering portrait was supplemented later by Neumeyer himself with the following warmhearted explanation: "It was the face of a suffering man, with deep shadows under his eyes, with the expression of tired nervousness on a head whose brutal proportions made this expression unbelievable and touching. The defensive attitude, his second nature, was probably augmented by the fatal illness which he already carried inside."

When I saw Beckmann for the last time in New York, in October 1950, I was perturbed by the tired and spent look of the sixty-six-year-old artist. I couldn't help thinking back to the almost frighteningly vital man, with the air of a Caesar traveling incognito, whom I had known so long and so well.

His very last letter, of December 25, had a sense of foreboding: "Yesterday I finished a new triptych and am rather pooped. It was a damned chore, and for many days I didn't know where my head stood, or fell. Well, now I have it behind me. Puh—."

Before this letter reached me, Max Beckmann died on December 27, 1950.

53. **California Park.** *1950. Oil on canvas, 55 × 24". Private collection, New York*

Biographical Outline

1884 February 12, Max Beckmann is born in Leipzig, the youngest of three children of a miller and grain merchant.

1894 His father dies, and the family returns to Braunschweig (Brunswick, Lower Saxony), the birthplace of his parents.

1900 Enrolls at the Grandducal Art School, Weimar, and studies with the Norwegian painter Carl Frithjof Smith.

1903 First trip to Paris.

1904 Moves to Berlin.

1905 Formation of the Brücke group in Dresden by Ernst Ludwig Kirchner, Fritz Bleyl, Erich Heckel, and Karl Schmidt-Rottluff.

1906 Exhibits with the Berlin Secession and Künstlerbund in Weimar. Receives the Villa Romana Prize and studies for six months in Florence. Marries Minna Tube, who had been a fellow art student in Weimar. Death of his mother.

1907 Returns to Berlin and settles in the suburb of Hermsdorf.

1908 His only child, Peter, is born.

1910 Elected to the Board of the Berlin Secession, but resigns in 1911. New Secession formed by Max Pechstein (who had joined the group) and other members of the Brücke whose work had been rejected by the Berlin Secession. The rejected artists opened their own Salon des Refusés concurrently with the Berlin Secession show.

1911 Formation of the Blaue Reiter group in Munich.

1913 One-man show at Galerie Paul Cassirer, Berlin. Hans Kaiser's monograph, the first on Beckmann to appear, is published.

1914 Enlists in the German army field hospital corps, and serves in East Prussia, Flanders, and Strasbourg.

1915 Receives army discharge for health reasons. Settles in Frankfurt am Main.

1917 Exhibition of graphic work at J. B. Neumann's Graphisches Kabinett, Berlin.

1925 Divorces Minna and marries Mathilde von Kaulbach ("Quappi"). Appointed professor at the Städelsches Kunstinstitut, Frankfurt, a post he will hold until 1933.

1926 First American exhibition at J. B. Neumann's New Art Circle, New York.

1928 Retrospective exhibition at the Städtische Kunsthalle, Mannheim. Also exhibits at Galerie Alfred Flechtheim, Berlin, and Günther Franke's gallery in Munich.

1929 *The Loge* is awarded honorable mention at the Carnegie International Exhibition, Pittsburgh.

1929–32 Max and Quappi spend each winter in Paris.

1930 Retrospective exhibitions at the Kunsthalle, Basel, and the Kunsthalle, Zurich.

1931 First exhibition in Paris at Galerie de la Renaissance; also shows in Brussels, Hannover, and New York.

1932 Begins work on first triptych, *Departure*; exhibition at Galerie Bing, Paris.

54. Beckmann in profile, Amsterdam, 1938

1933 Nazis come to power and Beckmann is dismissed from his teaching position in Frankfurt. His work is declared "degenerate" and is removed from German museums. Moves to Berlin.

1937 Emigrates from Germany on July 19, a week before the opening of the Nazi "Degenerate Art" exhibition in Munich; ten Beckmann paintings are included. Lives in Amsterdam and Paris. Settles in Amsterdam where he will remain until 1947.

1938 First of ten exhibitions at Curt Valentin's Buchholz Gallery, New York. Travels to London to deliver lecture "On My Painting" at the anti-Nazi "Exhibition of Twentieth Century German Art," at the New Burlington Galleries.

1938–39 Winters in Paris.

1939 His triptych *Temptation* is awarded first prize in the contemporary European section at the Golden Gate International Exposition, San Francisco.

1940–47 Spends war years in Amsterdam; hardships notwithstanding, this is a period of great productivity.

1947 Travels to Paris and southern France. In August, sails for the United States where he has accepted a teaching position at the School of Fine Arts, Washington University, St. Louis.

1948 Visits Chicago, Boston, and New York. First retrospective in the United States at the City Art Museum of St. Louis; the exhibition travels to major museums in Los Angeles, Detroit, Baltimore, and Minneapolis. Beckmann returns to Holland in the summer. Delivers lecture "Letters to a Woman Painter" at Stephens College, Columbia, Missouri (later repeated in Boston; St. Louis; Boulder, Colorado; Oakland, California).

1949 Teaches summer school at the University of Colorado, Boulder. Moves to New York to teach advanced painting at The Brooklyn Museum Art School. *Fisherwomen* awarded first prize at the annual exhibition "Painting in the United States, 1949," at Carnegie Institute, Pittsburgh.

1950 Receives honorary doctorate at Washington University, St. Louis. Teaches summer school at Mills College, Oakland, California. Signs permanent teaching contract with The Brooklyn Museum Art School. One-man show at the German Pavilion, XXV Venice Biennale; awarded Count Volpi Prize. December 27, Max Beckmann dies in New York.

56. Beckmann in his living room in St. Louis, 1949

57. Quappi and Max Beckmann on the occasion of Beckmann's receiving an honorary degree from Washington University, St. Louis, 1950

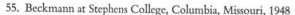

55. Beckmann at Stephens College, Columbia, Missouri, 1948

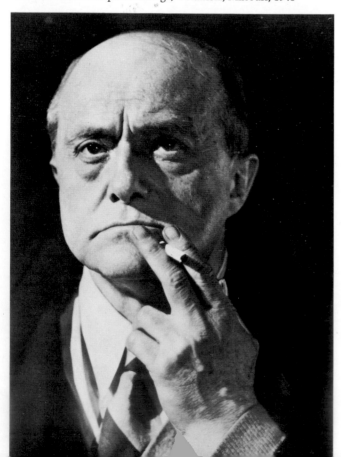

Colorplates

1. Self-Portrait in Florence

Painted 1907. Oil on canvas, 38 1/2 × 34 5/8"
Private collection, Murnau

This self-portrait by the twenty-three-year-old artist shows a considerable degree of technical expertise that is presented somewhat self-consciously, as if to demonstrate that he had indeed merited the Villa Romana Prize, which he had been awarded by the Künstlerbund in Weimar. The prize made it possible for Beckmann to work in Florence, and perhaps gratitude led him to show that city in the left background. The roofs and the lovely hills of Fiesole sparkle under a southern sky. The painter and the world are completely at peace.

Beckmann's technique was purely Impressionistic at that time. Even the three strict verticals of the window frame are dissolved into horizontal brushstrokes; a strange beginning for an artist whose structural black outlines were later to become the hallmark of his style. The artist's hand is presented in virtuoso fashion; it is technically better painted than the tortured, earthy hands of the mature master. But virtuosity is what makes this a journeyman's work —though a lovable one. The face is still soft, an ingratiating idealism shines forth from the eyes. The seriousness of the artist's endeavor is heightened by his formal black attire. Yet the light landscape, with its varied, shimmering greens, exudes a feeling of joie de vivre. The figure is not integrated with the background: a proud, aloof visitor stands before a foreign city which he finds quite enjoyable.

In spite of the flaky technique, it is apparent that the young artist was most deeply impressed by the cool, spare, incisive clarity of Luca Signorelli and Piero della Francesca, the Florentine Renaissance masters. Nothing in this self-portrait indicates that this was the year of Picasso's wild *Demoiselles d'Avignon* and of the bold experiments of the Brücke painters in Germany. As far as style was concerned, Beckmann was a latecomer to modernism.

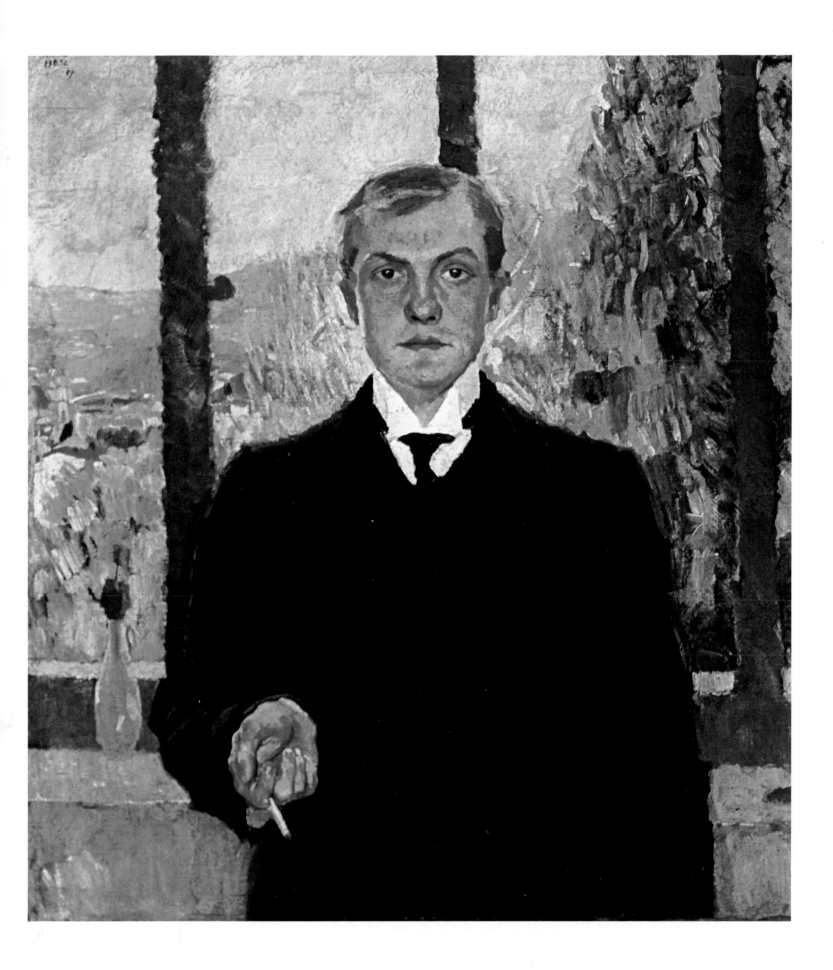

2. Self-Portrait as a Medical Corpsman

Painted 1915. Oil on canvas, 21 3/4 × 15 1/8″
Von der Heydt-Museum, Wuppertal

In September 1914 Beckmann enlisted in the German army field hospital corps. He served as a medic in East Prussia, and later in Flanders and Strasbourg. He was a good medic. For one year he changed dressings, cleaned operating rooms, helped to dissect corpses, read to the wounded, and even held a raving soldier down on his bunk all through one night. But whenever he had a free minute, he made drawings of life in trenches and operating rooms, of ruined villages and churches, of dead cows, and of his wounded brother-in-law. His superiors must have noticed that the constant danger and exertion were putting a heavy strain on Beckmann's nerves, and he was ordered back to the relative peace of city life in Strasbourg. "Here I'm sitting pretty," he wrote to a friend in October 1915, "drawing bacteria for the fatherland." He suffered a nervous breakdown and was discharged.

This *Self-Portrait*, painted in Frankfurt, is Beckmann's only oil painting directly utilizing his war experience. It is a simple, no-nonsense portrait of a man who has seen horror and degradation and has survived. Somewhat astonished, with wide-open eyes, he stares into a mirror: Well, here you are, you are still around, how strange. The lush and luxurious backgrounds we find in some of his prewar self-portraits have been eschewed for a cool, bluish wall. He simply shows himself in the act of painting; after a year of craving for brushes and paint tubes, he was glad to have a little time to grab a canvas and to manipulate a few colors. The red cross, like a decoration, holds the central place of honor; the artist is proud of his merciful function in wartime.

His numerous drawings of the horrors of World War I are much more explicit than the self-portrait, but when we know what Beckmann went through, we can find it mirrored in his unflinching glance. This is what these eyes saw: "Yesterday we came through a cemetery which was completely ruined by grenade fire. The tombs were ripped open, and the coffins lay around in uncomfortable positions. The indiscreet grenades had exposed the ladies and gentlemen to the light—bones, hair, clothing peeked out from the burst coffins." He continues this letter to his first wife Minna: "Oh I wish I could paint again, color is an instrument which I cannot do without for much longer. If I only think of gray, green, and white, of blackish yellow, sulfuric yellow and violet, a shudder of lust runs down my spine. Then I wish the war was ended and I could paint again."

Self-Portrait as a Medical Corpsman is executed with great assurance—no hesitation, no wavering is discernible. There is one indication of the coming revolution in Beckmann's style: the nose is seen slightly in profile whereas the mouth appears in frontal view. This is the very first expressionist distortion which, within a few years, would grow into a violent disruption of Beckmann's traditional perspective.

50

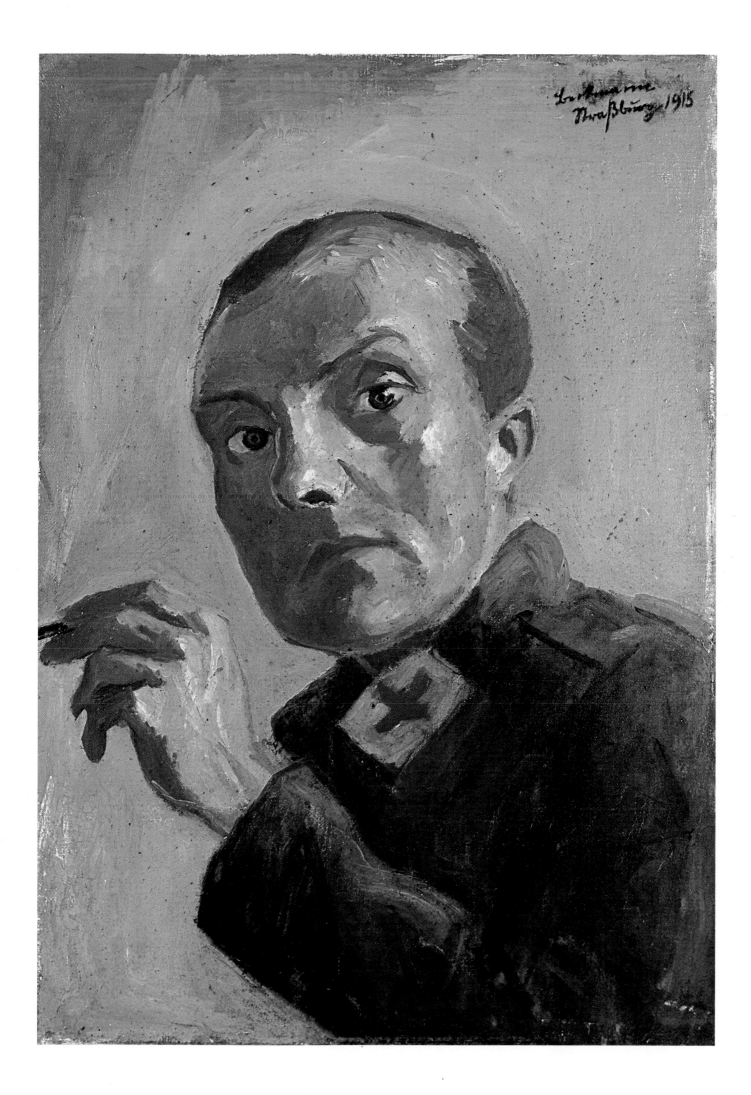

3. Christ and the Woman Taken in Adultery

Painted 1917. Oil on canvas, 58 3/4 × 49 7/8"
St. Louis Art Museum. Bequest of Curt Valentin

This picture could almost be called "a drama of hands." The variety and expressiveness of these hands and their gestures are incredible. If one could see nothing but Jesus' right hand, one would know that here a poor soul is being received into the mild, deep space of divine protection. Christ's left hand, shaped like an elongated Gothic arch, defends the sinner, pushing back insults and menaces. These gently energetic, almost elegant hands are counterpointed by the passive, soft hands of the adulteress praying in quiet confidence. The mocking, cruelly aggressive forefinger of the clownish scoffer; the rude fists shaking furiously in the air on the left; the lancer's hands bent back by the impact of the crowd's hatred—this is an assembly of characters in the shape of hands.

It is rewarding to follow their intents: the thrust of the mocker's index finger meets the conciliatory force of Christ's right hand; the supplicant's wave of devotion is conducted to heaven by Jesus' left fingers; and this same left hand collects and throws back, like a concave mirror, the scorn of the self-righteous accuser.

It is difficult to tell how many people there are in the re-stricted space of this picture. Utmost economy prevails; four spears stand for a whole troop of soldiers. The pattern of legs and feet forms a repeated angular design; one could not move a single limb without toppling the pictorial structure. Even the disjointed members symbolize the larger event, a never-completed congregation. This purposeful incompleteness was already used by Matthias Grünewald, and there are several other artistic devices that Beckmann learned from the early sixteenth-century master. The colors, too, are reminiscent of Grünewald's grisailles. These severely restrained grays, browns, and yellows are thinly painted; they appear almost transparent and give a strange lightness to the dramatic scene.

The figures are projected in extreme close-up. So close is the eye of the supposed spectator that it sees the feet from above and the shoulders from below. We are thus almost sucked into the narrow space of the picture; we must participate. We are made part of the age-old, eternal drama. Christ forgives the sinner, but He averts His face, avoiding any intimacy. "Go, and sin no more," He says.

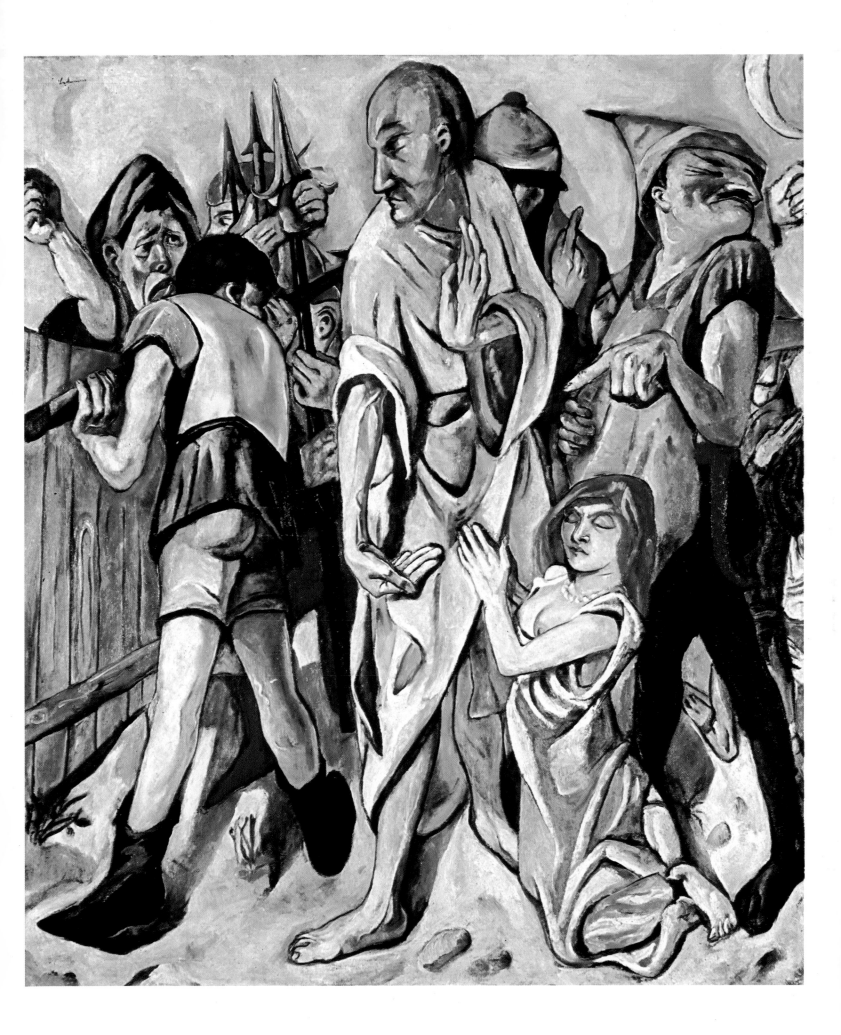

4. The Descent from the Cross

Painted 1917. Oil on canvas, 59 1/2 × 50 3/4"
The Museum of Modern Art, New York. Bequest of Curt Valentin

This *Descent* and the preceding work, *Christ and the Woman Taken in Adultery,* are companion pieces of almost identical size. After Beckmann returned from World War I—during which, as a field-hospital soldier, he had witnessed the most horrible scenes to which any man can be exposed—he was preoccupied with a series of religious paintings. From 1916 to 1918 he attempted a gigantic *Resurrection,* which he left unfinished, and in 1917 he also painted an *Adam and Eve* (fig. 11). The Christian concept of guilt and atonement became his leitmotiv for several years.

The Descent from the Cross shows a darkened sun, symbol of utter despair. The future itself seems blacked out. Beckmann borrowed this gloomy phenomenon from the Tegernsee altarpiece (attributed at the time to Mälesskircher) in Munich, which he had admired as a youth. It is no coincidence that this motif appears in Beckmann's art around 1917; he felt a strong inclination toward the "manly mysticism" of Northern Early Renaissance masters, and his new style was deeply influenced by their sparse, dour, hard-edged realism.

The body of Christ in its pitiful rigor mortis still reflects the shape of the Cross: this magic figure has now been imprinted indelibly on humanity. The entire canvas is spanned by the oversized corpse. The kneeling women are reduced in size, another stylistic device derived from Gothic and Early Renaissance art where it was used for the depiction of donors.

The upper end of the ladder is not visible, which gives us a feeling that the suffering Son of God has come down directly from outer space, a cosmic entity.

Beckmann was now working very slowly. From 1905 to 1913, as a self-confident, voluble young artist, he had painted an average of twenty pictures annually. Between 1916 and 1923 he created only from three to seven works each year. His productivity was channeled inward, with an extreme concentration; he now had to invent not only paintings but a new style. His works began to acquire Expressionist elements which made them true products of their time. As his artistic situation became much closer to that of the other German Expressionists, Beckmann joined the forefront of the artistic revolution which changed the concepts of European art.

In November of 1917, an exhibition of Beckmann's new graphics opened at J. B. Neumann's gallery in Berlin. On this occasion the artist formulated his program in a few laconic sentences: "The editor of this catalogue has asked me to write something about my work. I don't have much to prescribe: Be a child of your times—Naturalism toward your own ego—Objectivity toward inner visions. My love belongs to the four great painters of manly mysticism: Mälesskircher, Grünewald, Bruegel, and Van Gogh."

Objectivity toward inner visions: this part of the program was applicable to such paintings as *The Descent from the Cross.* And the imperative to "be a child of your times" led on to new and terribly exciting works—terribly exciting in the true sense of the words.

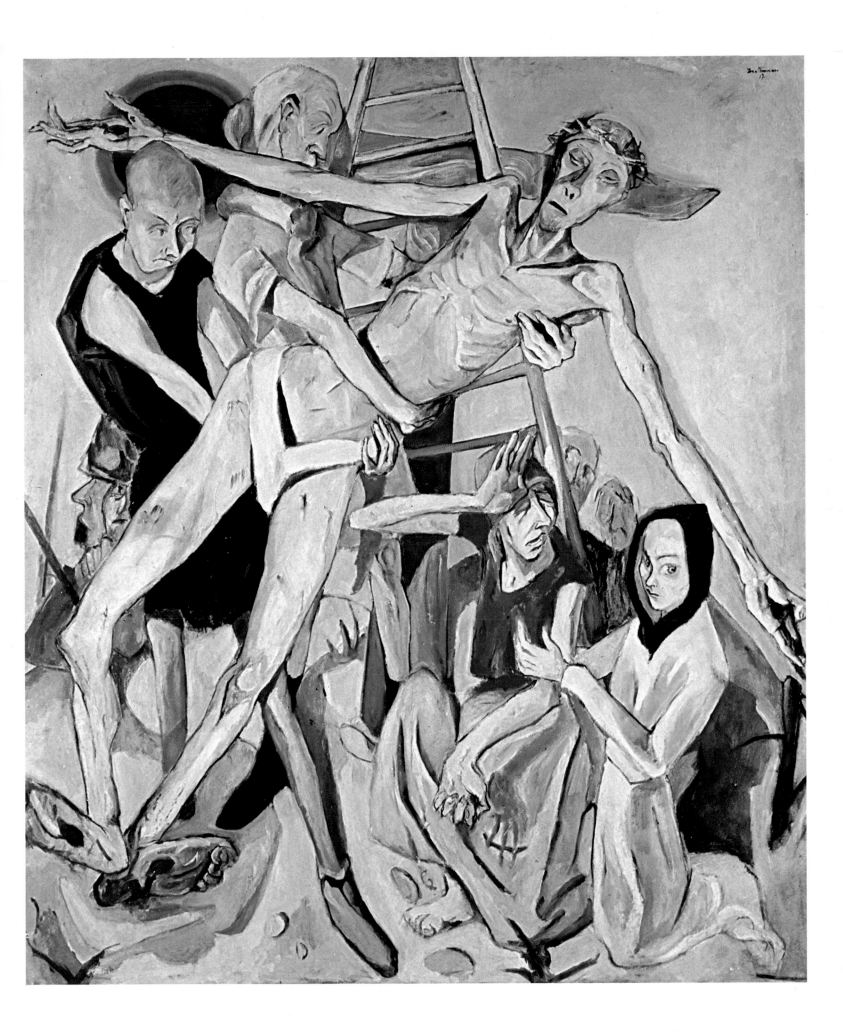

5. The Night

Painted 1918–19. Oil on canvas, 52 3/8 × 60 1/4″
Kunstsammlung Nordrhein-Westfalen, Düsseldorf

This is surely one of the most gruesome pictures ever painted. Other artists, usually motivated by the higher purposes of patriotism or pacifism, have shown the disasters of war, suppression, and martyrdom; torture and pain are often represented as the just deserts of sinners tumbling into hell, and the roasting and beheading of saints are depicted to serve the greater glory of God. But Beckmann sees no purpose in the suffering he shows; there is no glory for anybody, no compensation, no gloating over justice accomplished—only senseless pain, and cruelty for its own sake. Beckmann blames human nature as such, and there seems to be no physical escape from this overwhelming self-accusation. Victims and aggressors alike are cornered. There is no exit.

And yet, strangely, the composition is visually satisfying: it is jointed as by a master carpenter. That is the cruelest aspect of this work; it presents utter orderliness, as if to say: This is the way things are supposed to be, this is "regularity." Not only the design, with its parallels and complementary angles, demonstrates this perverted "law and order"; the colors, too, appear well spaced and thoughtfully distributed. The woman in the right foreground may be wearing a blue corset because the tongue of the strangled man in the upper left turned blue and the painter needed a color-equilibrium. The torturer's tie may be yellow in order to correspond to the yellow wax of the candles.

Beckmann has abandoned the Christian symbolism he used in previous works. There is no salvation in sight. One may consider the tiny window cross in the darkness outside as a symbol of hope, but otherwise the pressure in the tight little torture chamber is without relief.

This is one moment in one attic in Germany at the end of World War I. There is no past and no future. The phonograph blares in order to blot out the cries of anguish. Its tune emphasizes the newsreel actuality of this happening: this is the present, this is the world.

The complex psychological situations are boiled down to simple formulas. The young woman performing an involuntary split is menaced by the candle. The woman on the right, nonchalantly swept off her feet, will be unable to prevent the rape. The monkey-like sadist in the middle accomplishes his torture with scientific coolness, as if to test the degree of pain that a human being can stand. Only the dog on the left considers outside help as a possibility: he directs his howling away from the center, believing that there is somebody, something outside the confines of the frame. But he is not rational, of course!

The foreground shows, for the first time in Beckmann's oeuvre, the pair of candles which he later used again and again in still lifes and triptychs: one has fallen and given up its ghost; the other carries bravely on. It is as if the artist wanted to leave one glimmer of hope, one little flickering light to negate the whole of darkness.

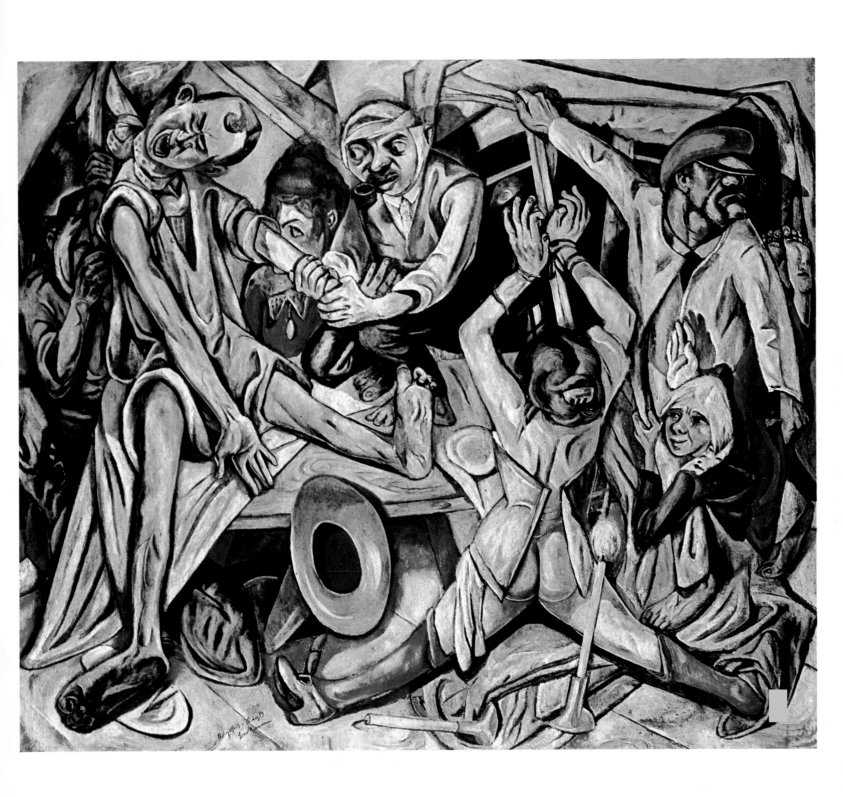

6. The Dream

Painted 1921. Oil on canvas, 71 3/4 × 35 7/8"
St. Louis Art Museum

On November 7, 1920, Beckmann wrote to J. B. Neumann, his art dealer and friend: "I think you'll be glad to know that *The Dream* has progressed nicely and begins to give me pleasure. With me that means a lot, since most of the time I'm in a state of deep anger. Which I'll probably be in again tomorrow. But today *The Dream* is so clear before my eyes as if I were asleep."

What a curious, yet highly artistic paradox: clear as if I were asleep. Many artists have pictured dreams as nebulous, fleeting fancies, but Beckmann's *Dream* is razor-sharp. It remains a clear picture of unclearness.

Each of the five characters is enslaved by a different illusion; each is trapped within his own shell of inhibitions and incapacities. The three male inhabitants of the cage are cripples. The drunken maid at the bottom is wrapped in a sexual fantasy and uses a cello as a substitute lover. Her face is flushed with excitement; her mouth smiles in coarse delight, but her eyes remain tightly closed to reality or reason. A yellow trickle at the bottom left corner shows what shabby relief fate has allotted her. We have to think back to Titian's *Danaë* and her golden stream of delight to appreciate the full measure of Beckmann's irony. But we really must look to Hieronymus Bosch in order to find similarly gross ideograms for the vengeance which reality inflicts on dreamers who disregard its laws.

War cripples, in those first postwar years, were a common sight and not at all a figment of the painter's imagination. However, Beckmann has added his own brand of ludicrous mummery to make the futility of patriotic sacrifice even more apparent. The legless cripple pushing himself forward on crutches wears an incongruously gay harlequin costume with polka dots that makes a mockery of his reduced state. A man in prison garb is climbing a ladder; however, without hands this seems a tricky undertaking, and in a moment he will reach the ceiling which will cut off his imaginary escape route. The young, innocent girl in the center has just arrived from the country and has already lost her way in the heartless big city. She sits helplessly on her trunk; her only companion is Punch, a grinning, soulless puppet; her watery eyes stare vacantly into an alien world. A blind beggar with hurdy-gurdy and silly toy trumpet completes the weird chamber concert, together with the cello and the mandolin. He hopes for alms, but there is nobody who can spare a coin. A card on his chest proclaims: "Thank God for the light in your eyes, and don't forget the poor blind man"—implying that God has probably forgotten him.

Forgotten, forsaken, caged in by fate and their own almost idiotic illusions—no common purpose unites this group of twentieth-century people. Only the strong formal scheme of their creator holds them together in a tight composition. The heads are equidistant, and the stiff limbs complement each other to form a cabalistic figure. The color patches also keep their distance, each color being repeated at regular intervals. What a frighteningly "conformist" dream this is!

Germany, through war, defeat, revolution, and inflation, was being reduced to a new minimum, and so was Beckmann's background, in a personal and in an artistic sense. In *The Dream,* his claustrophobic compression reaches its utmost density. There is no breathing space, no horizon. His stage has the atmosphere of a pressure cooker. Through this high compression Beckmann wished to force a new catharsis.

The window, which relieved the density of *The Night,* has now been replaced by an empty picture frame. This hieroglyph will remain part of Beckmann's vocabulary from now on, as will the stringed instruments with their ornamentally inverted scrolls. The fish with its slightly phallic connotation will reappear in many later works. And the organ grinder will again and again accompany Beckmann's *Lebenslied,* his song of life, with his fulsome and enigmatically sweet three-penny melody.

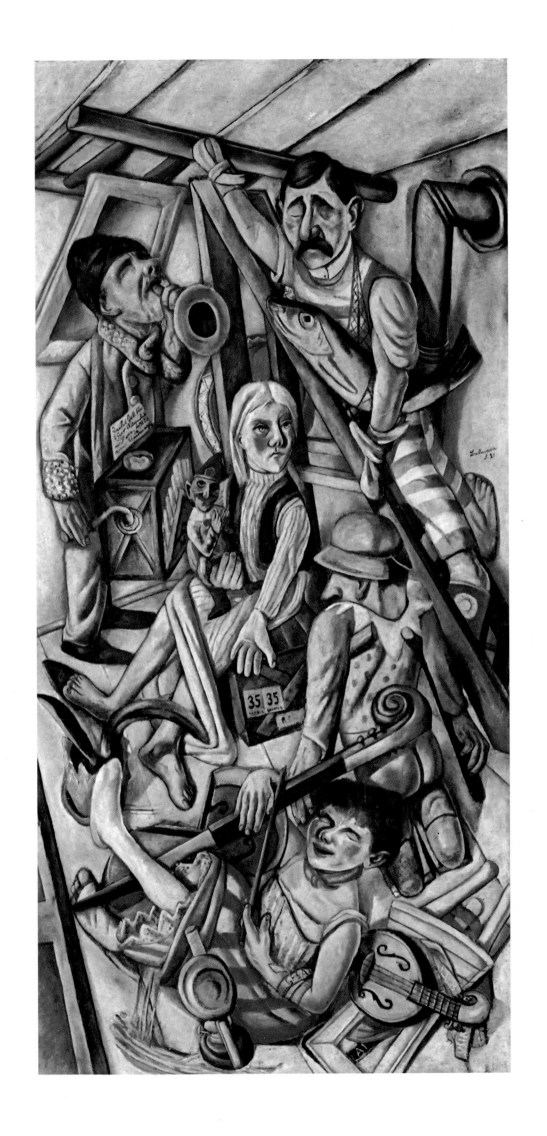

7. Dancing Bar in Baden-Baden

Painted 1923. Oil on canvas, 39 3/8 × 25 5/8"
Bayerische Staatsgemäldesammlungen, Munich. Günther Franke Collection

The rhythm and sparkle of this picture are reminiscent of a Stravinsky tango. There is sarcasm, but also fun and fascination. Sharp dissonances are held together by an exhilarating "beat."

The colors are iridescent like an oil film on a puddle, subtly indicating Beckmann's social criticism of the "upper crust." Changeable hues form an almost poisonous harmony evocative of the life-style of those years. The paillettes on the women's dresses are typical of the early twenties, as are the flawlessly white shirts that give their shady escorts the appearance of high respectability. The people depicted here are the profiteers riding the crest of the economic upheaval in Germany. Something is rotten in this state, but the painter's impartial eye sees beauty even in decomposition. The soap bubble of a phony boom can be beautifully tinted before it bursts.

In his drypoints and lithographs Beckmann criticized the nouveaux riches more savagely; painting in oil made him diverge from the harsh black-and-white simplification. The people who gathered in a hotel bar in Baden-Baden in 1923 impressed Beckmann with their haughty elegance, although he looked through their smooth façades and saw the cold brutality at their cores. He saw them as caricatures, certainly, but there is an admixture of admiration, too. He liked grand style wherever he found it.

Social criticism was practically a required course for an honest artist during those postwar years. George Grosz, Otto Dix, and other painters of the New Objectivity were, for a while, Beckmann's comrades-in-arms in the unpleasant but necessary activity of muckraking. Beckmann never quite managed the vitriolic treatment that Grosz dished out to the "Face of the Ruling Class." To Beckmann, the arrogant and ruthless bankers, politicians, officers, and robber barons always remained human. He even chose to paint them dancing, which was probably the most harmless of all their activities. And he gave them strongly individuated personalities.

The composition is beautifully organized. The ripple of the dance movement is indicated by the visual rhythm of the parallel arms, indicating the direction of the dancing couples. Seven hands point diagonally to the lower right. This strict pictorial vector, which makes the dancers swirl before our eyes, is counteracted by one hand in the lower left corner, and another in the upper right pointing upward at a right angle to the general motion. In this way the dynamic scheme becomes balanced.

There are so many figures in the limited space that the dance floor and the back wall are hardly visible. This crowd clings together, but not from mutual sympathy. Paradoxically, these men and women are unified by their utter egotism. They know exactly what they want to squeeze out of each other—the men want sex, the women money—but they enjoy the squeeze.

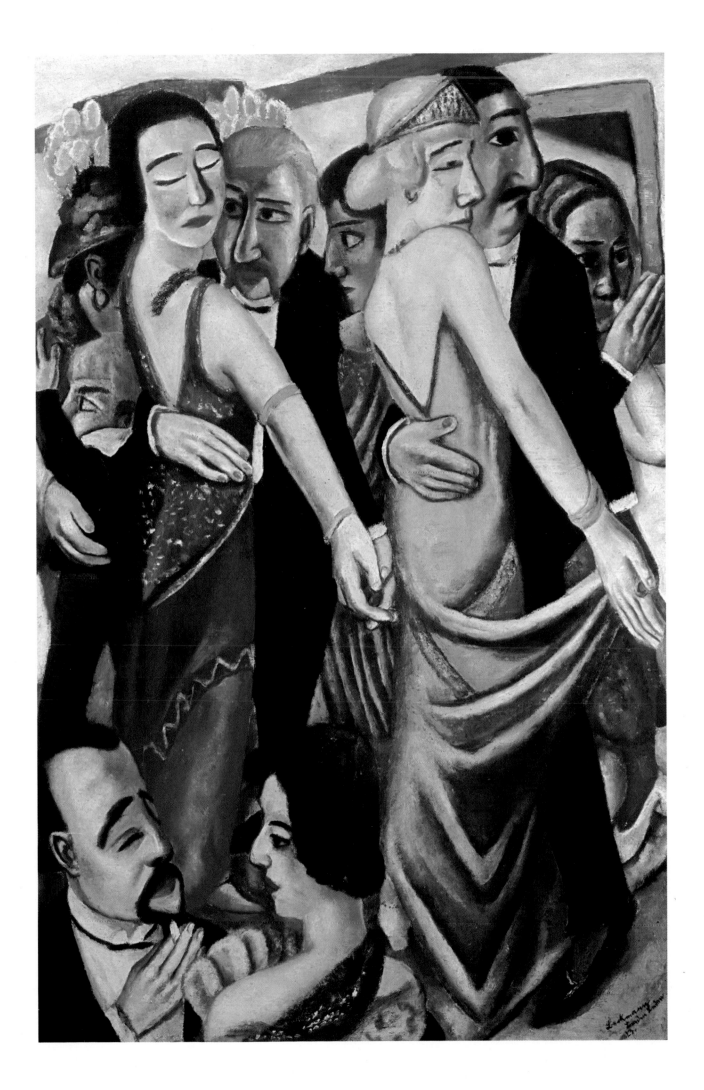

8. Landscape with Fishermen

Painted 1924. Oil on canvas, 23 3/4 × 23 3/4"
Kunsthalle, Bielefeld

A nice, cool, quiet summer day in a pleasantly civilized landscape. Nothing extraordinary happens; nothing is exaggerated, either by nature or by the painter. A row of poplar trees in the background indicates that a street is not far away; the two peaceful men with their fishing poles can probably hear an occasional vehicle driving by. The artist has not eliminated the smokestack in the distance; the industrial age is there, but it does not encroach upon the park or upon the pleasure of the "Sunday" fishermen in their bourgeois attire. The locale of this scene, still recognizable today, is the Ostpark in Frankfurt.

Nineteen twenty-four was a year of consolidation in Europe. Germany had accommodated herself to being a defeated nation earnestly seeking participation as a junior partner in international enterprises. The world had become an open proposition.

After his return from the war, Beckmann had painted people as though they were under terrifying strain, often in pressurized rooms. In *Landscape with Fishermen,* although the horizon is not explicitly shown, it is there. One can breathe freely.

The conciseness of form and the straightforward style of Henri Rousseau's individualized junglescapes come to mind. The lighted streaks along the blades of the reeds, the geometric shapes of trees and bushes, are not so much an imitation as an homage to the Douanier. Rousseau died in 1910, but his influence spread from France to Germany during the 1920s. Beckmann loved Rousseau, and, much later, in 1938, he wrote: "I thought of my grand old friend Henri Rousseau, that Homer in the porter's lodge whose prehistoric dreams have sometimes brought me near the gods."

Rousseau's simplification of form and technique had stimulated the creation of the stylistic movement in Germany called *Neue Sachlichkeit,* or New Objectivity. It was a reaction against the overstatement, the unrestrained outpouring of protest and ecstasy that characterized Expressionist poetry, theater, and painting. Beckmann, who had had his nervous collapse in 1915, needed some peace and quiet. In 1917 he had already stipulated as his aim: "Sachlichkeit den inneren Gesichten" (objectivity toward your inner visions). A trend emerged in 1923, when G. F. Hartlaub, Director of the Kunsthalle in Mannheim, originated the term *Neue Sachlichkeit,* and Dix, Grosz, Beckmann, and several minor artists exhibited in Mannheim in 1925 under that title. Even though these sectarians could not stem the mainstream of Expressionism, the side road to a somewhat more *gemütlich* world view was beneficial for Beckmann, artistically and personally. *Landscape with Fishermen* is one of the most pleasing results of that New Objectivity.

9. Carnival: The Artist and His Wife

Painted 1925. Oil on canvas, 63 × 41"
Kunstmuseum der Stadt, Düsseldorf

The artist with his young bride—Max and Quappi were married in September 1925—are out for an evening's entertainment. They have gone to considerable expense for preparations, and their costumes are chic and amusing. They arrive through the parting flaps of a curtain as if they were stepping onto a stage. Their faces are powdered and made up, and they obviously enjoy the masquerade. Beckmann's usually stern mien has loosened up, his expression is just on the threshold of a smile. He is proud of his pretty wife. Even though they do not touch, the parallelism of their hands conveys a feeling of harmony. The artist and his wife have made up their minds "to belong" and to have a good time. The viewer partakes of their good humor.

The color scheme is of tasteful subtlety. Primary colors are kept to a minimum. The purple, greenish, and russet hues are mixed with great finesse and have a velvety, highly cultured shimmer; in a word, the fabrics look aristocratic. Even the horse is not a makeshift prop, but is a rather luxurious toy to serve only for one evening.

Quappi, Beckmann's second wife, brought a light note into the tormented painter's life. An excellent violinist, much younger than he, from a well-to-do family, and very much in love, she may have been a distraction for the artist-moralist. Only two years earlier, when Beckmann was asked whether he would paint some war pictures, he replied: "Längst bin ich in anderen Kriegen" (I'm already in different wars). He regarded his art as a spiritual combat. But in 1925, he suddenly seemed to have concluded an armistice with his deeper problems. A great love of life inspired Beckmann at that time, and Quappi helped him to enjoy the present. The Beckmanns were popular with the artistically inclined society of Frankfurt, and Beckmann became the teacher of a master class. It may be noted that later on, when Nazi persecution, exile, hunger, cold, and danger changed their style of living, Quappi remained a most efficient helpmate. "She is an angel," Beckmann said, "sent to me so I could accomplish my work."

In 1925 this lay far in the future. At the moment Max and Quappi are two figures from a new commedia dell'arte: harlequin and a lovely horsewoman with a funny hat.

Illusion and reality melt into each other; there is no strict borderline between the two worlds, certainly not during carnival time. Beckmann often endeavored to confound the two spheres. Painting carnival and circus scenes, masquerades and costume parties, he found a whimsical way of philosophizing: Don't trust appearances, things and people are not what they seem to be. But Beckmann was willing to adhere to the rules of society's game—especially when it was an amusement.

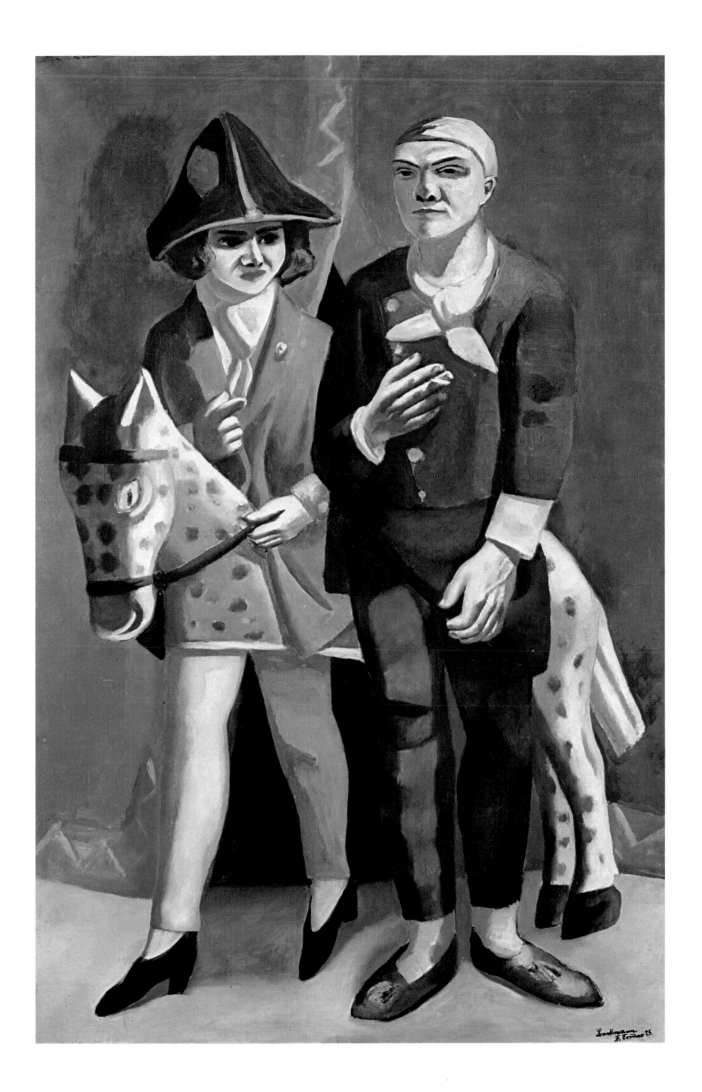

10. Viareggio

Painted 1925. Oil on canvas, 20 1/4 × 14 1/4"
St. Louis Art Museum

Empty windows exert a strange fascination upon many modern artists. Surrealism and *pittura metafisica* thrive on hollow buildings and senseless curtains. A human abode abandoned by all but the wind induces apprehensions that one does not like to admit, but its enigma is spellbinding. We wonder what happened in those shadowy halls.

It is possible that Cézanne's *La Maison du Pendu* (*The Hanged Man's House*) of 1873 inspired this substyle, perhaps more by its title than by the work itself. Later, the painters Giorgio de Chirico and Carlo Carrà would attain the desired spookiness through the very absence of ghosts.

Beckmann painted some houses that looked haunted, before 1914, but he loved the human figure too much to ban it from his pictures. *Viareggio* is his first work where the absence of any living being is striking. Not even a bird flies in the heavy sky. Sorrow seems to hover over the little street and in the empty windows. The high garden wall on the left is breached only by some drooping vines. The telegraph poles are not connected by wires, as if no communication were needed or even possible. In some earlier paintings Beckmann drew telegraph wires meticulously, but here they are lacking; there is no message going out. This is the end of the road.

In the distance, Beckmann suddenly surrealizes three sailboats. Their crews are not visible, and the unearthly glimmer of their sails seems to spread over the green sea. The light tones of pink and old gold provide a strange burst of unmotivated bliss. But the happy boats will bypass this melancholy shore.

Some zigzag patterns extend through the dust of the street. Probably, they were originally just indications on Beckmann's first charcoal sketch that he wanted to darken a certain region of his canvas. But then he grew to like their eerie shapes and expanded them into forms resembling snakes, which have the compositional function of guiding the viewer's eye into the distance. Still, at the same time, the shapes are the ghosts of those "snakes."

Franz Kafka, in his short stories, also has spectral boats approaching southern shores. This similarity of themes is not unusual. In any given period, intuitive crosscurrents between the various arts are fairly common among artists who never met or knew of each other's work. Although Kafka died a year before *Viareggio* was painted, he might have been able to tell us exactly what was going on in this whitewashed, enigmatic house.

11. Galleria Umberto

Painted 1925. Oil on canvas, 44 1/2 × 19 3/4"
Collection R. N. Ketterer, Campione, Switzerland

Modern artists generally avoid anecdotal subjects. Occurrences that happened only once are shunned as thematic material. History, once the lifeblood of academic art, is not as popular with twentieth-century painters.

We know that Mussolini was killed on April 28, 1945, by Italian partisans, and subsequently hung by his feet in the Piazzale Loreto in Milan. But do we wish such gruesome "great moments in history" to be immortalized? However, this scene was painted by Beckmann twenty years before Mussolini's death!

Erhard Göpel, an art critic who often visited Beckmann in wartime Amsterdam, gives the following account: "When, in 1925, he promenaded through the Galleria Umberto in Naples, he saw the flood of fascism rising, he saw carabinieri saving drowning people and a body hung upside down by ropes. He saw this in broad daylight. When Mussolini's fall was reported, he fetched the painting from the closet and showed it in his studio. He considered it a vision even before he knew that he had also foreseen the manner of the dictator's end—hanging head down."

Galleria Umberto contains many odd features, the strangest of which is the crystal ball hanging from the glass ceiling. Did Beckmann have clairvoyance in mind when he invented this translucent globe? Consciously, he probably wanted only to satirize the Italy of 1925. The fascists' murder of Matteotti was widely interpreted as a storm signal just then, and Beckmann feared that gay vacationland Italy, symbolized by the mandolin, the bather, and the tootling blonde, might be swamped by political repression. An Italian flag is drowning already in the foreground.

Expressionist art offers several examples of this uncanny "second sight," the most literal being Ludwig Meidner's views of bombed and burning cities painted in 1913. Beckmann pictured the Frankfurt synagogue in 1919 with its walls slanting as if they might topple at any moment. But we need not really ascribe supernatural powers to artists. Fantasy, in itself already a miraculous faculty, suffices to explain many predictions, such as Tennyson's when he "Saw the heavens fill with commerce, argosies of magic sails,/Pilots of the purple twilight, dropping down with costly bales;/. . . and there rain'd a ghastly dew/From the nations' airy navies. . . ." Tennyson, who died in 1892, did not see his prophecy come true. Beckmann did.

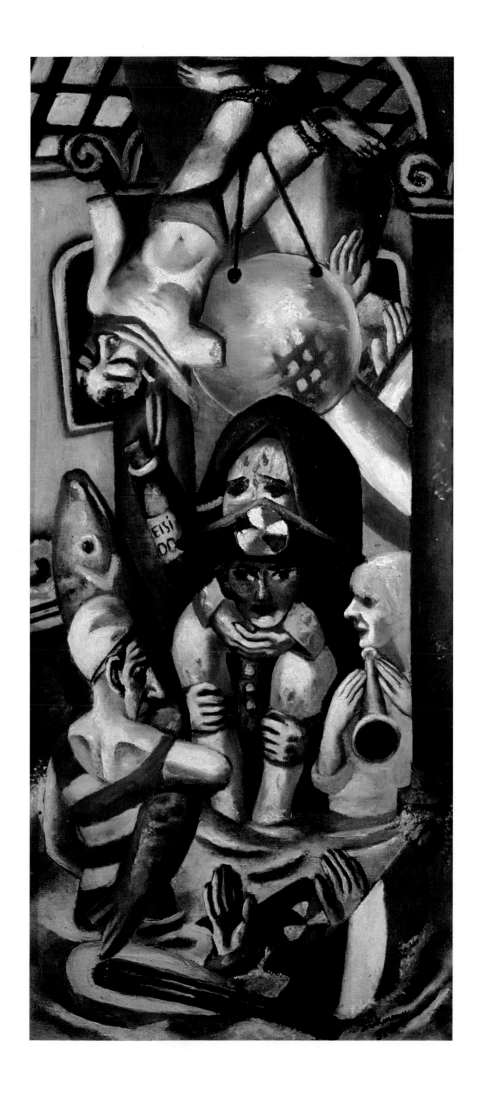

12. The Dream (Chinese Fireworks)

Painted 1927. Oil on canvas, 19 3/4 × 24 3/8″
Bayerische Staatsgemäldesammlungen, Munich. Günther Franke Collection

Ambiguity pervades this picture. Nothing is exactly what it seems to be, reality has become unreliable. The telegraph wires along the lower edge could also be a fence to keep the crowd in check. Innumerable people are clad in black as for a funeral, yet they are assembled for a gay festivity, something like a Chinese New Year celebration. The buildings in the background resemble a railroad train, with the sun as a signal device. There are three giant balloons: a clown and an elephant, standing on their heads, and a fish floating upside down. They are weightless, blown topsy-turvy by a light breeze, but in spite of their friendly colors they hold an indistinct menace, as if they might turn around and attack the unsuspecting multitudes. The sun is beautiful, but is it really our sun? The varicolored rings around the dark nucleus make us think of a giant Oriental ornament.

Beckmann liked to call some of his painted fantasies dreams, which gave him the opportunity to juxtapose divergent phenomena so that their absurdity would become obvious. This was the purpose in the much bigger, much more ambitious *Dream* of 1921 (colorplate 6) and in the lithograph *A Dream of War* of 1946. *The Dream* of 1927 does not appear to have the social or pacifist purposes of the other dream pictures. The artist only wants to show the double meaning, the equivocation underneath the apparent solidity of the objects around us.

The Beckmann of 1927 was a painter and nothing but a painter. From 1916 to 1925 he had created an amazing number of lithographs, drypoints, and woodcuts. In 1926 and 1927 he did not produce a single graphic work. There was no outward cause for this sudden renunciation; his graphics had been quite successful. He must have felt that his métier as a painter had reached the sort of perfection that permitted him to realize all his intentions with oil on canvas. And in looking at the colors of *The Dream* we can understand why: lovely soft tints are set off by strong, velvety blacks and greens. The colors are a pure delight.

Dreams were usually visualized by Romantic artists as misty and nebulous. In Beckmann's *Dream* there is not the slightest haze: the atmosphere is clear and luminous; his is a shadowless world. The farthest objects show up as distinctly, or as indistinctly, as the closest ones. Distance is not indicated by an atmospheric mellowing of the colors, not even by any linear perspective; there are no diagonal lines leading into the background. Without such guidance the viewer's glance flies as if into an abyss, seduced by the clarity and transparency of space. This clarity, which contradicts all the various equivocations of the subject matter, makes the picture more dreamlike than any mist could; somehow this is a twentieth-century dream.

Did Beckmann actually paint a dream he had had at some nocturnal hour? Or did he formulate his double meanings consciously? We cannot know. But, as Seneca said: "Only he who is awake tells his dreams."

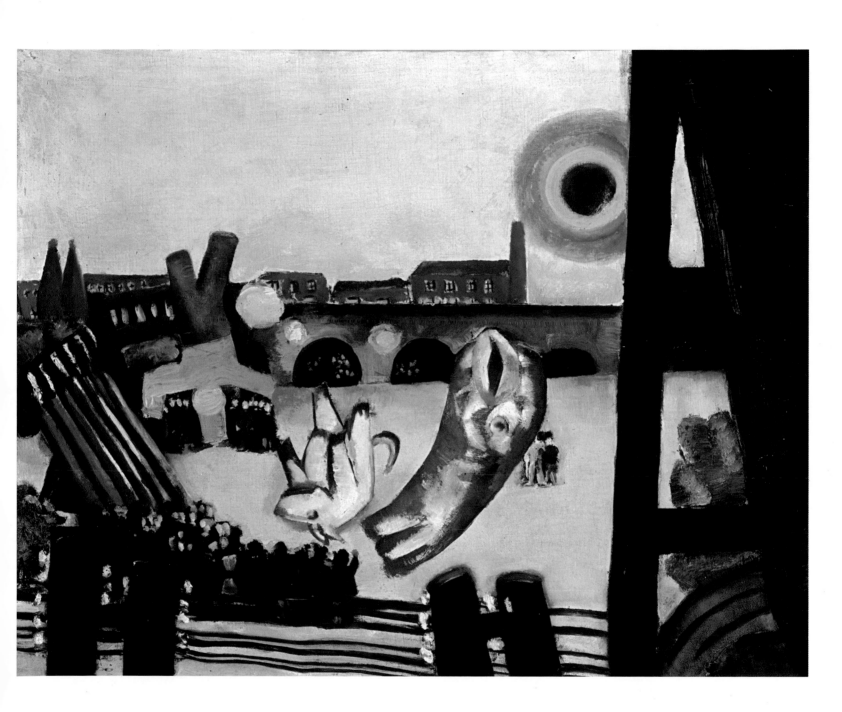

13. Self-Portrait in Tuxedo

Painted 1927. Oil on canvas, 54 1/2 × 37 3/4″
Busch-Reisinger Museum, Harvard University, Cambridge, Massachusetts

Any self-portrait has to be self-centered—this is to be expected from the genre. But the man who confronts us here is frankly egocentric.

Nothing indicates that he is an artist. He could be an industrialist or a politician; he is obviously successful. He appears to be a man of purpose and hard work, but now he is relaxed. He seems relatively good natured—though it would be unwise to cross him.

Symmetry here becomes a symbol of security. The face is partitioned into symmetrical patches of light and shadow. Every feature rests in itself. Reliability is shown in the perfect equilibrium; the stance is reminiscent of the classical contrapposto of heroic statues. The closed contour proclaims a self-contained human being. The man's left hand is moved over to the middle of the picture; thus, both well-lighted hands together form a counterpoise against the background, which is dark on the left and light on the right —a delicate balancing act. Everything is quietly clarified, distilled into a rational formula. The undiluted contrast of black, white, and brown gives a feeling of clean stylization.

Another major self-portrait comes to mind, one that emanates a comparable conscious superiority and barely avoids the borderline of arrogance: Albrecht Dürer's frontal *Self-Portrait* of 1500, which depicts the artist with flowing locks. There, too, symmetry symbolized the height of life. It is entirely possible that the date 1500, distinctly displayed on the painting, gave Dürer a mystical feeling of being exactly in the middle of his time. The Beckmann we see in the 1927 self-portrait was indeed in the middle of his creative career. In 1905 he had destroyed all his earlier oil paintings to prove to himself that his apprenticeship was over, and he lived and painted until 1950. Therefore, 1927 was the halfway point of Beckmann's journey. The mystique of the symmetry is uncanny.

Beckmann adopted many disguises in numerous studies of his own person; like Dante, he wanted to know himself *per tutte guise*. Here he is simply a gentleman. Does he consider this a disguise also, or does the elegant man in tuxedo take himself altogether seriously? Whatever the answer, Beckmann surely thought that life and success would continue in the grand style for quite a while.

This painting has evoked some violent opposition. The critic Fritz Stahl, in 1928, objected to its *boche* arrogance: "A Caesarean mask, frowning forehead, tyrant's stare, every inch the great man. These faces have to disappear again from our world if humanism is to be reconstituted." In contrast, Heinrich Simon, the publisher of the *Frankfurter Zeitung,* wrote in 1930, "that this lonely maverick may become the only personality in European painting who, by his example, will form a style for the future." And Peter Selz, writing in 1964 about this same *Self-Portrait in Tuxedo,* calls it "one of the great self-portraits in the history of art."

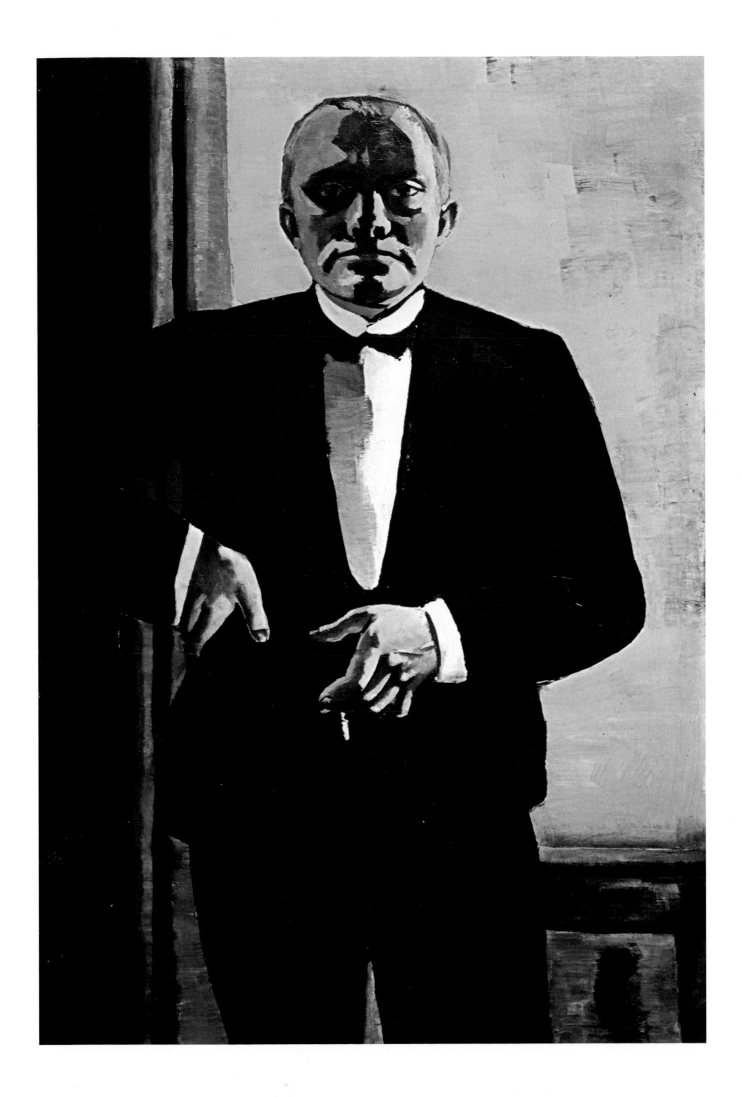

14. Black Irises

Painted 1928. Oil on canvas, 29 1/2 × 16 1/2″
Collection R. N. Ketterer, Campione, Switzerland

At first glance this seems a very simple still life: four flowers in a vase, two or three on the table as if waiting to be rearranged, some sheets of music, the round back of a chair, wallpaper, and a curtain: nothing much, really. And yet, what a wealth of extremely sensitive gradations within the few chosen colors!

Green and black, both velvety and richly saturated, form the basic harmony. The crosses on the wallpaper appear, by contrast, more reddish than they actually are. These crosses lean to the right, the curtain rim is slanting to the left; each line is in correspondence with every other line. If the wallpaper motif is a reminiscence of Cézanne, the unified composition owes even more to the French master.

Black irises: we feel Beckmann's wonder and astonishment that they really exist, that some botanist or gardener succeeded in breeding this almost unnatural phenomenon. The painter savors the black, from its gray shades up to the whitish reflection on the lighted side. Beckmann always insisted that black is a color, not the absence of all colors, and with the substantial black pigment in this painting he proved his point artistically, if not scientifically. Admittedly, then, black is a color when Beckmann uses it.

This artist, relentlessly driven by the demons of his times and of his own temperament, relaxed when he painted flowers. Often his harshest figure compositions, his most unworldly triptychs, are brightened unexpectedly in some corner by a bouquet. Blossoms give him the most unproblematic painterly delight, and—a rarity with Beckmann—they speak for themselves only, without standing for a deeper philosophical idea. His "terrible furor of the senses" becomes tender and gentle when dealing with blooming plants.

Beckmann loved the innocence and gratuitous sheen of flowers that ask nothing from us except to be loved.

15. The Loge

Painted 1928. Oil on canvas, 47 5/8 × 33 1/2"
Staatsgalerie, Stuttgart

A lady looking out from the frame of a theater loge or from a shaded balcony was a favorite subject of many painters; Goya, Manet, Renoir, and others used this compositional device. One interpretation of this theme is that the balustrade protects and restricts the enticingly beautiful woman, so that the gentleman at her side has nothing to fear from the ogling males below. But is his trust justified? Usually, in this genre of painting, the lady appears to have her own thoughts, and her eyes have a bold glimmer unnoticed by her companion or chaperon; the protective framework allows her to display her charms more nonchalantly than she might otherwise dare. Her escort feels secure in his squarely indicated property rights—overly secure, possibly—and in the versions by Renoir and Beckmann he holds opera glasses before his eyes and leaves her unobserved. A subtle sea change takes place in her psychology, and she lifts her chin a little. Her attractive eyes have found a new target—a target at least for her thoughts.

Precious jewels and flawless attire belong to this theme, and Beckmann's *Loge* is no exception. The severely restricted color scheme indicates high-strung elegance. The stark contrasts of light and shadow give an electric sparkle, the tension of a somewhat artificial social event. Traditional subject matter and Expressionist novelty of treatment combine to make this one of Beckmann's most felicitous creations.

Small wonder that it immediately gained a high degree of recognition. *The Loge* was awarded honorable mention at the Carnegie International Exhibition of 1929. Also in 1929, one of Germany's leading art critics, Julius Meier-Graefe, bestowed on the artist the highest praise: "Once more we have a master among us, God knows how this happened to us." And he acquired *The Loge* for his own collection.

Exactly what spectacle this couple is witnessing is not known. The program resting on the balustrade reads FAMA, which may indicate Beckmann's wishful thinking or philosophical preoccupation at that time. However, we can be certain of one thing: the play on stage could not have been half as fascinating as the beautiful lady in the loge.

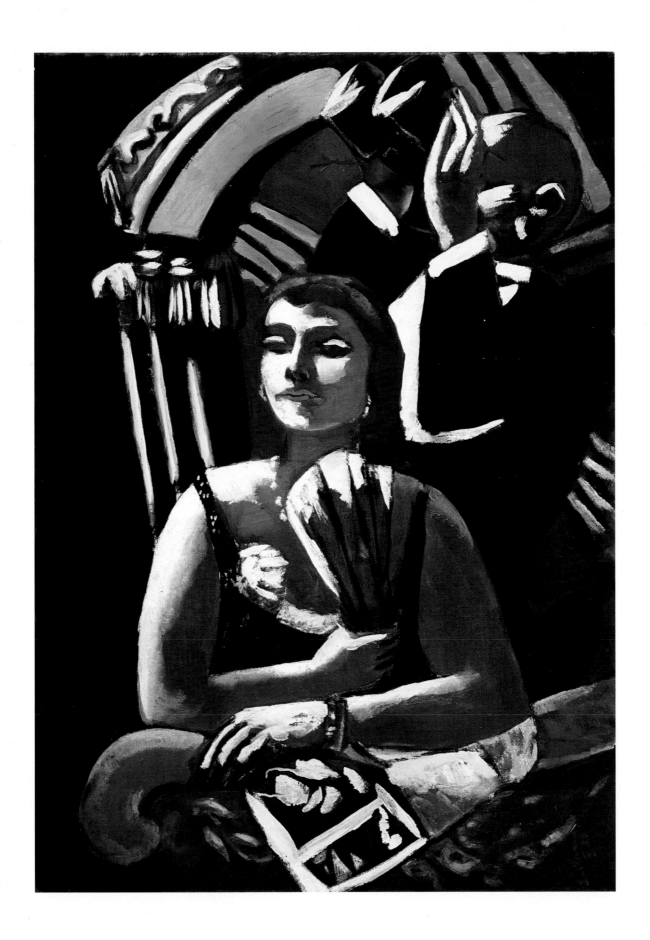

16. Rugby Players

Painted 1929. Oil on canvas, 83 7/8 × 39 3/8"
Wilhelm-Lehmbruck-Museum, Duisburg

In this painting Beckmann worked out what must paradoxically be called "controlled spontaneity." The paradox goes even further: the split second becomes timelessness, the spontaneous happening freezes into a rigid monument without losing its original impetus.

The headlong rush of muscular bodies is converted into a solid, well-balanced composition. Heads, boots, and hands appear at approximately equal intervals on the canvas. The ball, high in the sky, is unobtrusively complemented by the circular opening of the megaphone lying on the ground. The severely limited local colors are applied in a satisfyingly regular pattern, and the broad areas of color create a checkerboard of multiple contrasts. The arms form a zigzag ladder, conveying the impression of lightning speed.

The rough-and-tumble game gives the viewer a heady, breathless feeling: the competition aims for the sky. There are overtones of freedom, joy of movement, and liberation of the body, which, in 1929, certainly made this picture appear ultramodern.

The strong influences of Fernand Léger and Robert Delaunay on this work are so obvious that they cannot have been accidental. Beckmann wanted to meet the French painters on their own ground. "Paris, here I come!" this picture seems to proclaim, "Everything you can do I can do better!" Whereupon Beckmann spent many winter months in 1929–32 and 1938–39 in Paris. It was extremely important for any artist at that time to receive the stamp of approval from the art capital of the world. Beckmann did not really succeed in this endeavor; he enjoyed only lukewarm recognition. But the influence of Paris on Beckmann was beneficial, for his art became more international in scope.

And Beckmann did have two successful shows in Paris: at the Galerie de la Renaissance in 1931, and at Galerie Bing in 1932. Even Picasso was impressed. "Il est très fort," he was heard to say.

Strength is indeed the most characteristic quality of *Rugby Players*: sheer bodily strength, strength of coloring, and the spiritual strength that combines two seemingly incompatible phenomena—spontaneity and monumentality.

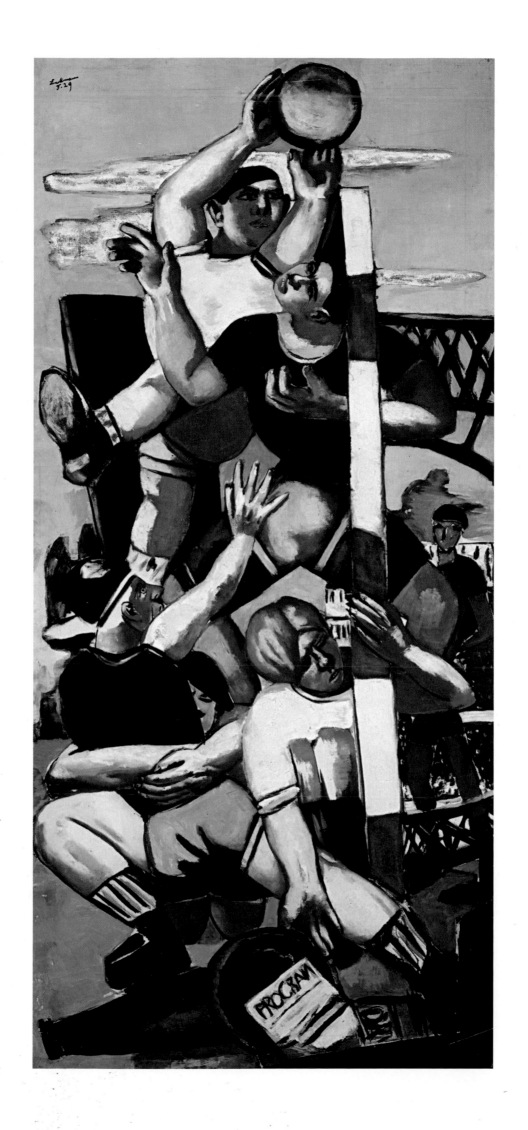

17. Self-Portrait with Saxophone

Painted 1930. Oil on canvas, 55 1/8 × 27 3/8"
Kunsthalle, Bremen

Max Beckmann has probably made more self-portraits than any other major artist since Rembrandt. It was certainly not vanity that suggested this subject matter to him. Even to the casual observer, his face betrayed a powerful, complex, and quite extraordinary personality; and a painter is justified in selecting any interesting motif which pleases him. He chose to paint his own person in order to study a wide range of human emotions.

His biography—or his fate—can be deciphered from his features as they changed through the years. We can sense that the *Self-Portrait with Saxophone* was painted in Paris. The colors are tastefully mixed and almost charming. But the decisive, firm, very masculine design is typically Germanic. Here is a German painter visiting the French capital that he loves. Beckmann and his wife Quappi wintered in Paris from 1929 to 1932; the influence of the School of Paris and of the gentle French atmosphere dissolved some of the harshness of the artist's earlier Nordic style.

In spite of its creamy, velvety tones, this painting gives an impression of great strength. Face, hands, and horn are modeled with sharp contrasts of shadow and light. The musical instrument is not literally a saxophone. It resembles a sensuous dragon that must be subdued; it is a creature with a life of its own. A refreshing vitality emanates from the bold, self-confident figure.

Beckmann may have selected the saxophone as his attribute in order to appear up-to-date, a modern man. The saxophone was a frivolous newcomer to the orchestra in the twenties, a kind of exotic clown; it symbolized the break with musical tradition effected by American jazz. Beckmann was fond of this kind of spicy entertainment. He wanted to be "a child of his time," and he accomplished this in the self-portrait of 1930. Yet this sober, thoroughly contemporary figure has a mythical aura. Hidden under the civilized appearance is a dragon-killer.

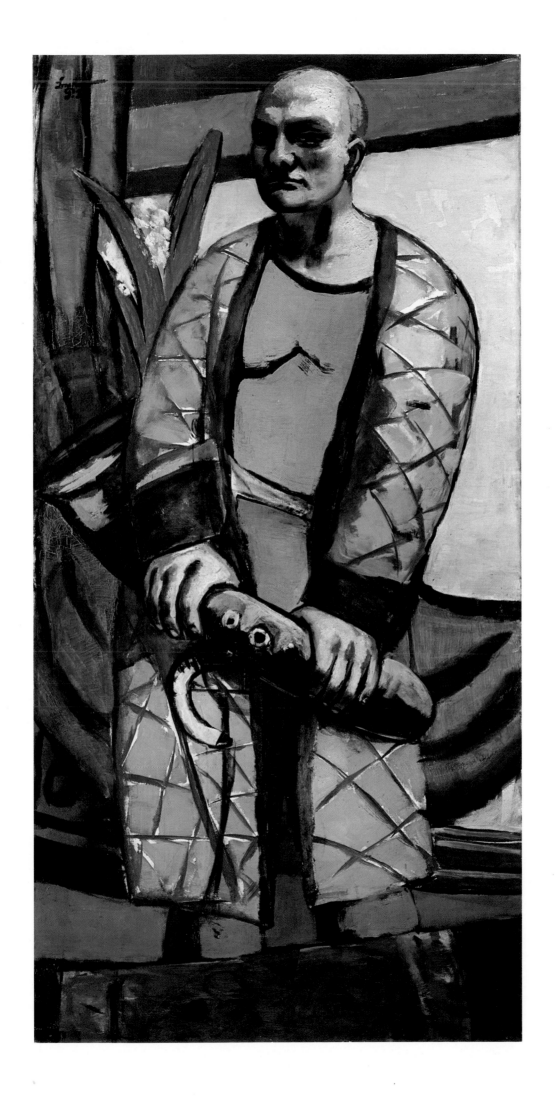

18. Still Life with Candles and Mirror

Painted 1930. Oil on canvas, 28 5/8 × 55 1/4″
Staatliche Kunsthalle, Karlsruhe

Several candles, some burning, some fallen over and extinguished: this was one of Beckmann's favorite allegorical subjects. An earlier treatment, very similar to the one illustrated here, was acquired in 1929 by R.W. Valentiner for The Detroit Institute of Arts—the very first Beckmann canvas to enter an American museum. Two candles, one flaming upright and one fallen, had already appeared in the foreground of *The Night* of 1918–19 (colorplate 5). These animated objects recur in his triptychs of 1941 and 1945 and in *Still Life with Orchid* of 1947. Sometimes their warning—how easily a light or a life may be snuffed out—is combined with the poignancy and futility of a wake, as in the bitter drypoint *Mourning the Dead* of 1924, where the smoldering candles no longer profit the deceased.

There is a simple, rather touching old German song, "Freut euch des Lebens, weil noch das Lämpchen glüht" (Enjoy life while the little lamp is still glowing). Hardly the stuff that still lifes are made of, and yet Beckmann manages to express this sentiment with his waxen cylinders.

A strange melancholy radiates from these poor, ineffectual candles nodding to their mirror images. They do not really illuminate the scene; the light in the picture does not emanate from them; there is clear daylight all around; their efforts and sacrifices are quite superfluous. They do not even produce shadows. No wonder that one of them has given up the struggle and lain down to rest.

Those who search for influences in art history may point out a certain rapprochement between this painting and the works of the School of Paris, especially those of Georges Braque. The exquisite harmony of the few select colors in this still life derives from Beckmann's experience during his sojourns in Paris. The beautifully swinging curves of curtain, vase, and candlesticks owe their stylishness to the same source. Even the use of a printed word in the center of the canvas may have its origin with the Parisian painters. But whereas the Cubists frequently employed the names of alcoholic beverages, Beckmann's inscriptions usually had mystical overtones. In this case, the book standing upside down on the table bears the title EWIGKEIT (eternity). The irony is clear; the flickering lights are consuming their own bodies in order to shed some parting rays on the eternal word. And yet Beckmann's "messages from the cosmos," as he called his inscriptions, are never didactic. Sometimes they only increase the enigma of his fantasies.

The word *Ewigkeit* recurs in several of Beckmann's works. A watercolor of 1936 shows a dressed-up, hairy monkey writing EWICHKEIT (Berlin dialect) on a poster: a truly sarcastic comment on one of our favorite illusions. However, the 1930 still life is not as bitter. Though a mild sadness is induced in the beholder, the message of these candles is not a hopeless one. Even a tiny, flickering light can be multiplied through the mirror of art.

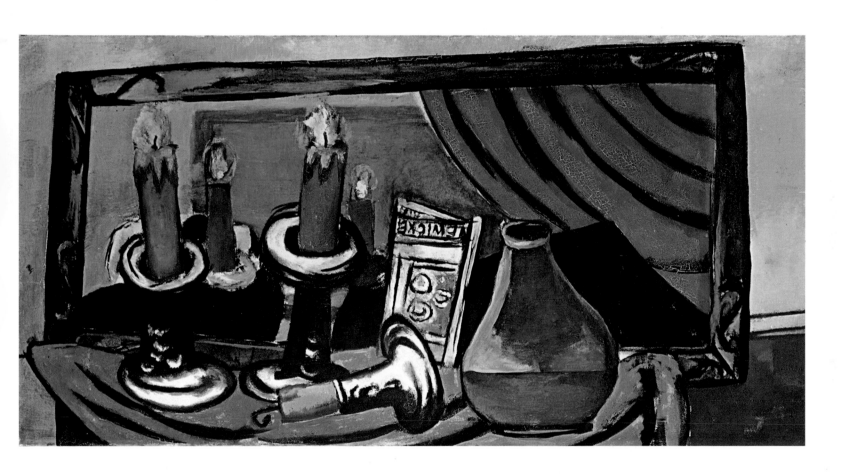

19. Party in Paris

Painted 1931 (reworked 1947). Oil on canvas, 43 × 69″
The Solomon R. Guggenheim Museum, New York

The people assembled in this room were, no doubt, invited to enjoy a private concert, but they are not paying the slightest attention to it. In the upper middle portion of the picture, a tenor—his proud stance identifies him as such —is singing his heart out. He sends his melodies over the heads of the audience, and we can see and almost hear his exertion. The pianist, seated a little farther to the left, melts into the background. Nobody acknowledges the performance. Perhaps the artist wanted to poke fun at a society that has cultural pretenses but ignores true art.

There is not only satire, but also admiration, in the way Beckmann portrays this gathering of Parisian high society. The participants are individualized to the extreme: this is the stock-in-trade of caricaturists from Leonardo to Daumier and Grosz. The more grotesque a face appears, the more unforgettable it becomes. The ladies' noses encompass all possible forms—the ski-jump, the hawk's-beak, the almost Greek straight—and yet three of these women could be called beautiful. Even the ugliest guests are painted with a marvelously incisive brush.

When Renaissance or Impressionist artists portrayed a group of people, they generally gave them a vectorial coherence: faces were directed toward the spectator standing before the canvas, toward a common focus—as in Rembrandt's *Night Watch*—or toward a sports event or other spectacle. Beckmann, however, shows a fragmented society, a gathering of uncommitted individuals. This gives the group an air of slight decadence. Each character is not only unique, but convinced of his own uniqueness. These people experience no genuine communication; each is wrapped up in his or her own significance. Beckmann's sharp, critical eye has registered that at a party of this sort exactly as many heads are turned away from each other as there are faces pretending to notice others. And not a single face is turned toward the poor singer in the background!

The citizens Beckmann presents are obviously important, intelligent, polished, wealthy, and interesting in their own way. Counteracting the satirical intent is the flawless elegance of their dinner jackets and haute couture. The male custom of dressing in black dinner jacket, stiff white shirt, and black tie had become quasi-universal in those years. Films of the period show it to be practically the uniform of "good society" after dusk. Yet it is surprising how rarely the tuxedo found its way into major works of art. Despite the fact that its simple black-and-white contrast lent itself easily to treatment in the woodcut medium, and that woodcuts, in turn, frequently dealt with social criticism at the time, Beckmann may be the only painter who depicted the tuxedo in a straightforward manner. In this way the black-and-white male attire served him in *Self-Portrait in Tuxedo* of 1927 (colorplate 13) and in *The Loge* of 1928 (colorplate 15). Later on evening clothes acquired sinister connotations: the singing angels in *Death* (1938) and the Minotaur in *Blindman's Buff* (1945) make these garments appear very macabre. The dinner jackets in *Party* seem to evoke just a trace of awe.

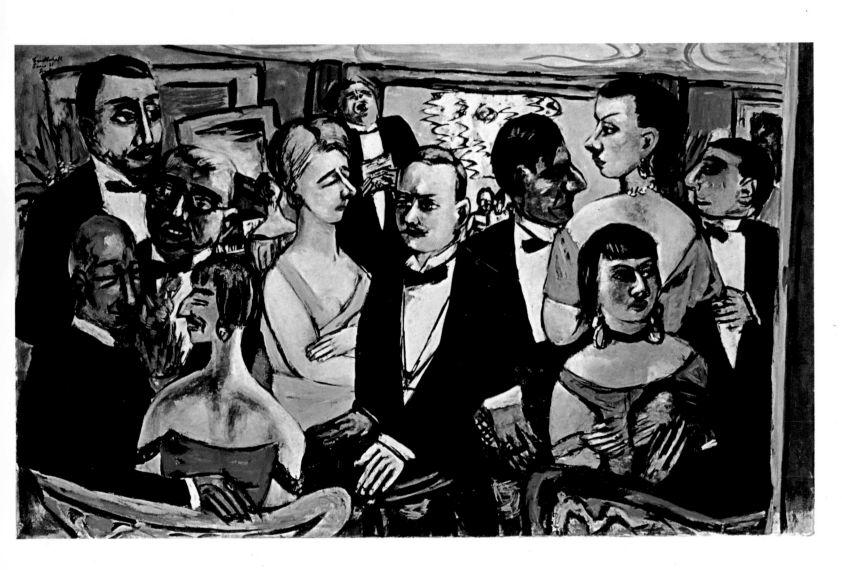

20. Man and Woman

Painted 1932. Oil on canvas, 68 × 48"
Collection Dr. and Mrs. Stephan Lackner, Santa Barbara, California

Man and Woman of 1932 has a mural-like quality, with the grittiness and chalky lucidity of a cinquecento fresco. The title, the barest formula, can mean Adam and Eve, but there are overtones of a weary Odysseus turning away from the nymph Calypso and her surfeit of honey and bloom. The man has abandoned the self-absorbed female; he has overstepped the horizon, and looms like a distant giant in the pale blue sky.

This sky, of an extraordinarily luminous shimmer, conveys a "wild surmise" of very early times, of a prehistoric dawn. And yet, for the man time is growing late; he is looking toward distant purposes; his muscular torso is quietly poised for more interesting and far-reaching deeds. He has the eternal longing of the wanderer. The tree behind the man has already shed its seeds; stem and empty pods are dried out; the sap of life has vanished from his side of the picture. The woman, curled contentedly around a flower in a feline attitude, still considers her little paradise as self-sufficient. Her tree is succulent, rank with buds and blossoms, almost lasciviously fleshy.

There are biblical reminiscences here of the Tree of Knowledge and the Tree of Life in the Garden of Eden. Sexual connotations, perceiving some vegetative forms as lingam and yoni, have also been discussed. The symbolism is reticent, almost secretive; however, we feel a strong mythical undercurrent, the vibrating tension of human culture *in statu nascendi*.

The colors exert an almost hypnotic charm on the retina. The painting gives us the feeling that we have a vast, free future before us, that we are looking into the clear, cool dawn of history.

Figurative art knows two entirely different kinds of nudity: we might call them positive and negative nudity. Negative nakedness means deprivation, misery, freezing, or hellfire. Positive nakedness means enjoyment of freedom, which can run the gamut from radiant innocence to explicit sexuality. Beckmann, in his graphics and oils from 1916 on, had mostly shown negative nakedness, as a corollary of deprivation and pain. But the 1932 *Man and Woman* proclaims, almost with programmatic intensity, the positive aspects of the nude human body. It presages a new period in Beckmann's work, a style which also comprises the most vital elements of classicism. With this painting Beckmann attained artistic universality.

In 1918 he had evolved the geometrical, sharply defined style of "the cylinder, the sphere, the cone," following Cézanne's precept; in 1932 he developed a liberated, loose, intense style, which was his own version of Expressionism. The geometrical fretwork was dissolved, allowing the works of the thirties to revel in spontaneity. Beckmann became the master of the living, excited, and exciting brushstroke. He continued to work for weeks and months on a painting, sometimes with long intermissions. But even in the most careful execution he rarely overpainted his first conception—as he had been apt to do in the early twenties—and therefore his new classical figures never seem dulled by academic tradition. He knew when and where to stop in order to let his pigments breathe, so that his characters always retain a dash of temperament. This man and woman are individuals, no doubt, with very personal characteristics, yet, at the same time, they are symbols of the male and female principles.

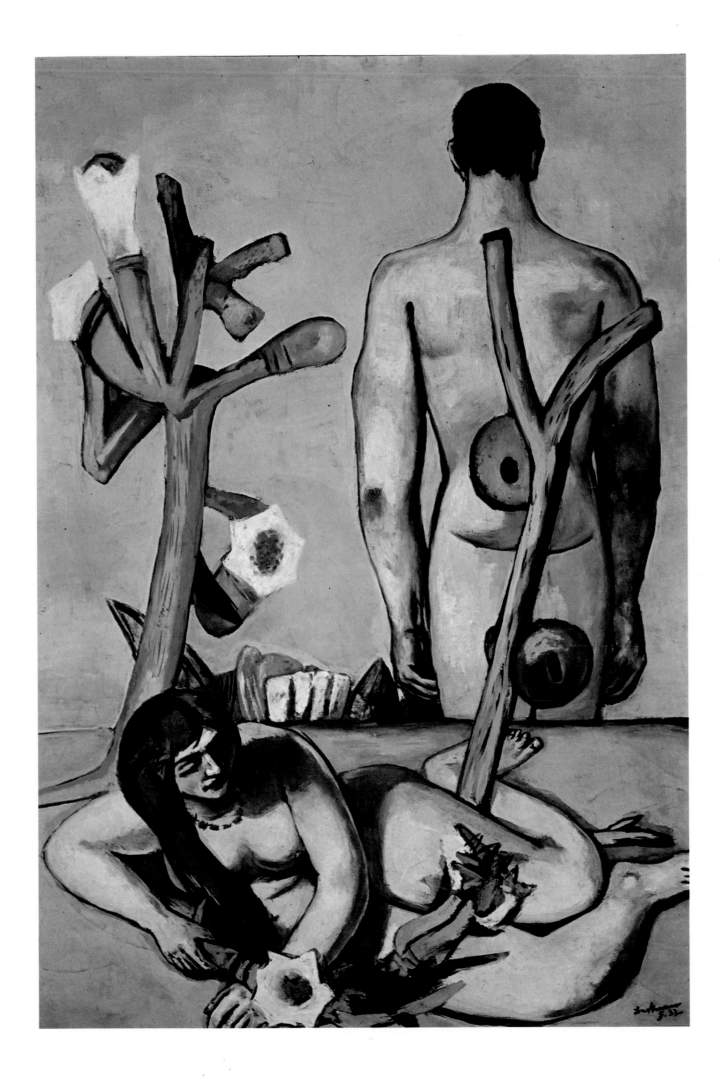

21. Departure

Painted 1932–33. Oil on canvas; triptych, center panel 84 3/4 × 45 3/8"; side panels each 84 3/4 × 39 1/4"
The Museum of Modern Art, New York

"Departure, yes departure, from the illusions of life to the essential realities that lie hidden beyond." Such was Beckmann's comment when his dealer, Curt Valentin, asked for an explanation of this triptych.

Lilly von Schnitzler was one of Beckmann's early patrons. In a letter to Alfred H. Barr, Jr., on June 1, 1955, she recollected an explanation the painter had given her in February 1937 when the triptych was still standing in his Berlin studio:

Life is what you see right and left. Life is torture, pain of every kind—physical and mental—men and women are subjected to it equally. On the right wing you can see yourself trying to find your way in the darkness, lighting the hall and staircase with a miserable lamp, dragging along tied to you, as a part of yourself, the corpse of your memories, of your wrongs and failures, the murder everyone commits at some time of his life—you can never free yourself of your past, you have to carry that corpse while Life plays the drum.

And in the center?

The King and Queen, Man and Woman, are taken to another shore by a boatsman whom they do not know, he wears a mask, it is the mysterious figure taking us to a mysterious land. . . . The King and Queen have freed themselves of the tortures of life—they have overcome them. The Queen carries the greatest treasure—Freedom—as her child in her lap. Freedom is the one thing that matters—it is the departure, the new start.

The pictorial vision of *Departure* must have existed in Beckmann's mind before any literary or ideological program; therefore, many of its enigmatic figures and their actions elude verbalization. The men and women populating this three-act drama are presented with almost frightening clarity; nothing is clouded, there is no lack of visual definition. A difficulty arises only if one tries to put the functions of the characters into words and sentences.

It may be more congruent with Beckmann's intentions for the viewer to first feast his eyes on the beautiful still life of fruit in the left panel, and on the magnificent sweep of the azure ocean and sky in the center panel. Perhaps Beckmann wished his audience to be confused, for confusion is what is represented in the side panels—abased and abused humanity. We are meant to stare in horrified disbelief at the tortures and ugliness in the wings. And then, suddenly, we are drawn to the center, to the whole and holy beings who are being saved. This triptych thus combines utmost suffering and highest bliss.

Several millennia seem to glide by, as we glance from the Assyrian supermen and the Grecian queen with her Phrygian cap, to the drummer in Renaissance costume, to the modern bellhop. Finally the future appears: in the center of the triptych, all the rays of hope and high expectation are focused on the golden-haired little boy.

One leitmotiv that links the three panels is the fish. In Beckmann's private mythology the fish represents the transcendent life force; sometimes this life force has slippery phallic aspects, sometimes it symbolizes the elusive soul. The drama starts in the left wing: a gangster-like ruffian has caught two fish in his deathly black net; their heads and tails protrude. Has he captured the souls of the two fettered and tortured men being victimized among the heathen temple columns? He swings the fish toward the center panel—are they to be rescued from the pain and confusion of our gruesome present?

No literal story is being presented here, only half-hidden meanings of fleeting dreams. What about the blindfolded bellhop on the right? The uniformed hotel attendant is a favorite figure in Beckmann's iconography, and the painter did explain him once verbally: "Today fate makes its entry on stage in the shape of a liftboy." He, too, carries a fish, as if it were a message, and he hurries after the couple "wrapped up in each other," as if to tell them that their union will remain dead without the slithery, elusive life force. The saga of the fish does not end there: at the bottom of the center panel, a swarm of "small fry" is being released from a fishing net, but one enormous fish is carefully carried off in the barge. The hooded oarsman secures this prize catch with special care, as if to say: What matter if the unimportant multitude escape, as long as we have the kingly trophy?

There is a wealth of other thought-provoking imagery. The corseted woman in the lower left panel stares into an empty crystal ball of illusion while leaving the huge, succulent, palpably "real" fruit at her side unnoticed. The man at the upper left forms an ironic contrast with the two fish in the net behind him; he is forced to stand in a barrel of water while they have been deprived of their life-giving element—a bitter joke worthy of a Bruegel.

Viewers may interpret the various allusions according to their own experiences. What is important is the almost hallucinogenic artistry that welds confusion and clarity, hideousness and radiant beauty, into a unified whole.

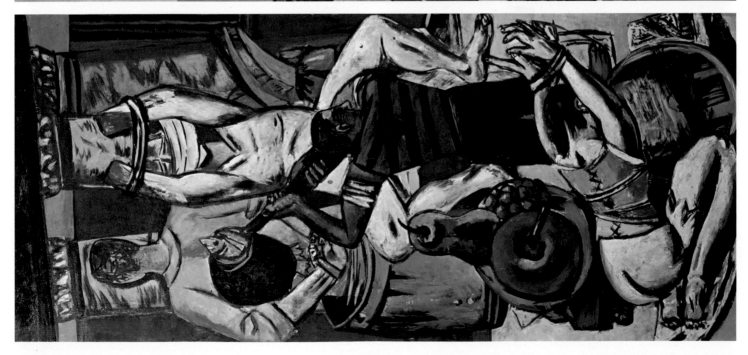

22. Brother and Sister

Painted 1933. Oil on canvas, 52 1/2 × 39"
Collection Dr. and Mrs. Stephan Lackner, Santa Barbara, California

The figures in Beckmann's *Brother and Sister* seem like magnificent creatures of Nordic mythology. Yet neither the medieval Nibelungen sagas nor Richard Wagner's operatic cycle contain this occurrence of forestalled incest. It is Beckmann's own mythic invention. The painting depicts that moment when primeval vitality is being conquered by civilization's laws and frustrations. The oversized sword that separates the loving siblings is the pictograph for humanity's cruel but necessary taboos.

The almost barbaric and yet strangely aristocratic figures have tumbled down on pillows and princely gowns. But the man has thrust his sword between himself and his sister; his hand continues its motion, which is converted into a secretly loving approach. The girl places her fingers on the blade, half-regretting and half-acknowledging its presence. The viewer's eye hovers above the figures, looking down on their shoulders in violent foreshortening; no anatomic realism is intended.

The tremendous force of the vision has not precluded lovely psychological nuances. Note, for instance, the two parallel lines of the profiles. Usually when two profiles are painted facing each other, the resulting design is a symmetrical mirror image, which, often awkwardly, prevents their unification. But Beckmann fits them evenly alongside each other in a continuous response, so that a black abyss seems to be bridged by their invisible vibrations. Or note the wide, unnaturalistic rounding of the brother's knee at the upper edge of the canvas; this establishes a formal correspondence with the round curve of the sister's buttocks. The sweep of these two curves holds the composition together as if in parentheses. The structural distortions give the scene a sense of inevitability. It is condensed to essentials, like a Gothic escutcheon.

Sometimes one glance at a work of art fixes it indelibly in the viewer's memory. The image seems to be the one valid formulation of an exactly circumscribed idea. If memorability is a criterion for artistic value, then Beckmann's *Brother and Sister* is of the highest rank.

This quality of instant impressiveness cannot be explained or defined, but it is one of the strongest emanations we can receive from art. To give a familiar example: millions who have no detailed knowledge of Michelangelo remember the outstretched hand of God the Father transmitting the spark of life to Adam's finger. Rodin's *Thinker* has it. Since Vincent van Gogh painted his *Sunflowers*, one can never again see these flowers in art or in nature without being reminded of the finality of Vincent's formulation.

It seems to me that Beckmann's work *Brother and Sister*, in its love and renunciation, has this quality.

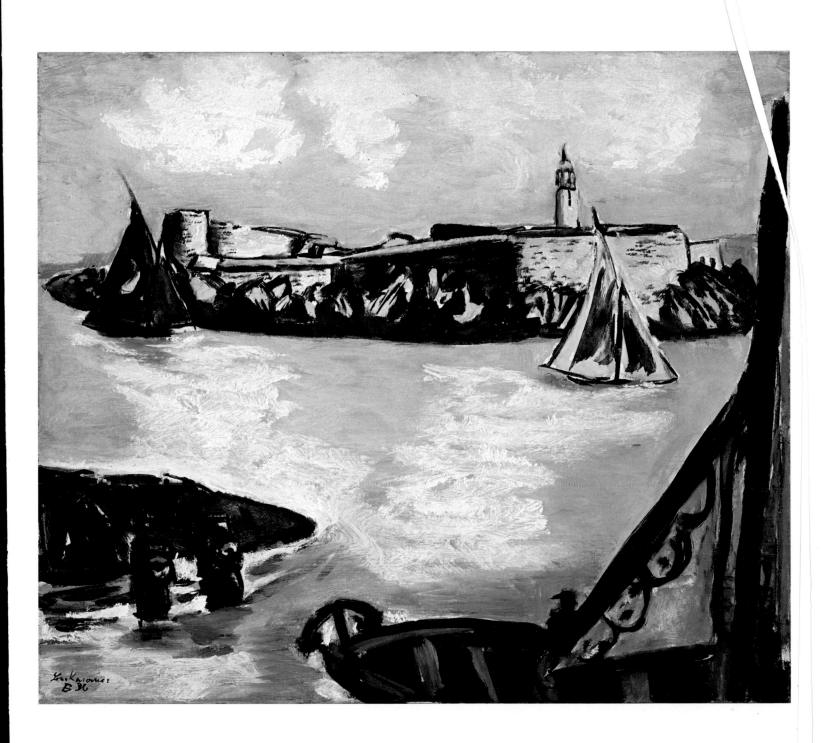

24. Temptation

Painted 1936–37. Oil on canvas; triptych, center panel 78 3/4 × 67"; side panels each 85 × 39 3/8"
Bayerische Staatsgemäldesammlungen, Munich

Temptation (often referred to as *The Temptation of Saint Anthony*), the second of Beckmann's nine triptychs, was painted in Berlin before the artist went into exile. Full of foreboding about the bellicose Nazi politics, Beckmann retreated into a world of personal ideology. He explored the hidden forces deep in the human soul that cause the upheavals erupting at the surface of our everyday existence. His triptychs are certainly splendid storytelling, but they have the ambivalence of dreams. They do not illustrate existing fables.

The very center of *Temptation* contains the germ cell of the unfolding drama. A bluish black iron idol with two heads embraces itself. Beckmann may refer here to the ancient Diana of Ephesus, or to the Chaldean myth that Oannes taught concerning the origin of mankind: "Men had one body, but two heads—the one of a man, the other of a woman. They were, in their several organs, both male and female." This tale persisted throughout the antique world. Plato tells us that these bisexual beings were so contented and blissful that the gods became envious and split them apart with a sharp sword; since then the two sexes, with burning passion, crave reunification to heal their wounds. Sigmund Freud developed the psychological validity of this idea that each psyche contains components of both sexes. Beckmann, in his diary, declares: "The whole thing is an enormous self-mirroring, established so we can enjoy always anew our Atman, the Self. And we have to admit that this trick—to partition ourselves into male and female—is really a fabulous, almost unending stimulus to drag us around by a tight rein."

The two emanations of this hermaphroditic idol are seated in front of it among sacrificial flames. Are they themselves offerings to the deity? The young man looks like a simple shepherd; his ankles and wrists are bound together, and the shackles appear to be made from the same metal as the idol. His profile shows a touching, classical beauty; this may be the handsomest male face that Beckmann ever created. The young man gazes steadfastly at the woman flaunting her fleshly charms, but, restrained by his fetters, he knows that he can never attain her. She averts her face, languidly holding a tired lotus flower. The atmosphere is filled with quiet tension, and the room is a strange mixture of artist's studio and pagan temple. A standing column appears to be steadying the idol, but another column has fallen—as if, in the foreground, dissolution of the heathen world had already set in—with the Christian message "In the beginning was the Word." Both the youth and the seductress seem to have emerged from the picture frames behind them; the painter's fantasy figures have come to life.

The temptations presented in the side panels are of a worldly nature; the youth disdains them in favor of his fate-ordained love. The Athena-like warrior in silvery armor in the left panel represents heroic action; she seems to indicate to the boy that he, too, should go out to slay monsters. The swarthy sailor invites him to oceanic adventures and exotic discoveries. Half-nude captive women await their liberator in vain. The young bellhop in the right panel is about to serve the shackled youth with a crown and a female slave. Beckmann's parrot of fame is ready to introduce him to high society. But the poor boy has eyes only for his beloved. The seductions of the rainbow-colored, wide world are not enough of a temptation to break the hold of silent, faithful devotion.

The sensual, luscious quality of the pigments is quite extraordinary and makes it clear that this is not painted literature; it is overwhelmingly visual art. True, there are allusions to Gustave Flaubert's *The Temptation of St. Anthony*, among other books, but none which would provide the "key" to the meaning of this picture. (Beckmann's title in his handwritten list of his works is simply *Versuchung* [*Temptation*]). No literary knowledge is required for the understanding and, above all, for the enjoyment of this vast and mysterious triptych; it is open to multiple interpretations. As Beckmann himself has put it: "Certain last things can only be expressed through art, otherwise they need not be put into painting, poetry, or music."

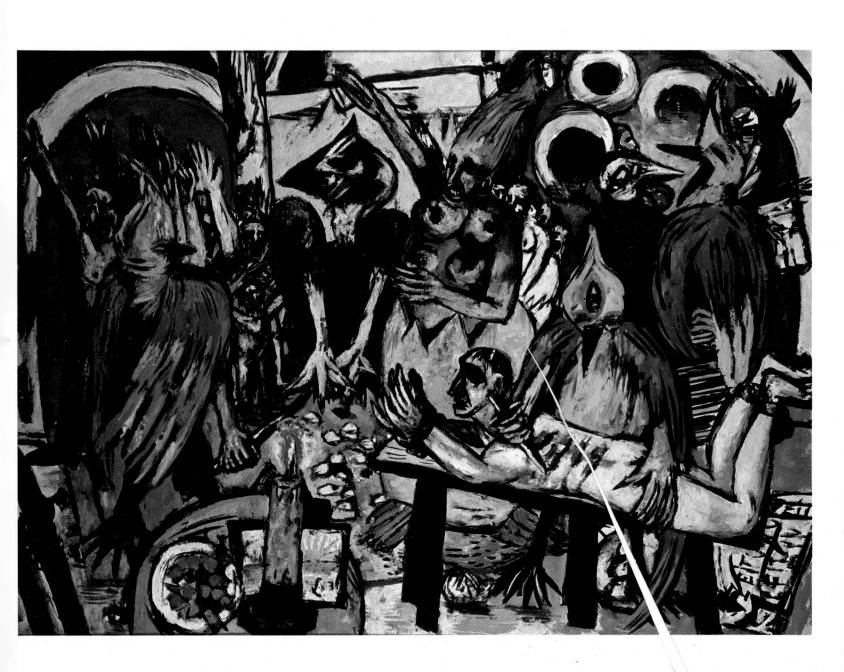

27. The King

Painted 1934–37. Oil on canvas, 53 1/4 × 39 1/4"
St. Louis Art Museum

The crowned king sits in his palace, in Oriental splendor, proudly erect, surrounded by two women. The young, beautiful lady on the left seems utterly trustful and loving as she puts her right arm over his thigh and fondles his left arm. The older, dark woman whispers conspiratorial advice into his ear; her cowl gives her an air of intrigue and secrecy, and her left hand is pushed forward in a gesture of warning or rejection, apparently contradicting the naïve, friendly creature on the other side of the monarch. The young blonde has his love, no doubt, but the older woman "has the king's ear." The king weighs the two influences silently. There is a strange, portentous atmosphere in the palace chamber. When will he arise and proclaim his decision?

The king's features are akin to Beckmann's own, although no formal self-portrait may have been intended. The collar with its triangular flaps has the shape the artist usually assigned to clown and harlequin costumes, so we may suspect that the ominous scene is really just part of a play.

Beckmann worked on *The King* for a long time. He must have considered it already finished in 1934, for he had it photographed in Berlin, three years before his emigration (fig. 33). He submitted it to the Carnegie International, where it was exhibited in the European section, in San Francisco, in 1934–35, and illustrated in the Carnegie catalogue. The painting did not win a prize. Disappointed, Beckmann changed the first version considerably and finally signed it in Amsterdam in 1937. This history of the painting is important because some commentators have seen allusions to the "despot" of the day and claim that this was the first painting that Beckmann created in exile. But the resemblance to Beckmann himself precludes any reference to the actual tyrant. No—this is the inner drama of a proud, powerful, benign individual.

In the first version, the base of the column at the right edge of the painting resembled the bases of the columns of Persepolis. Beckmann at the time was immersed in studies of Tel Halaf, and Assyrian and Babylonian lore. This localization of the scene gave way, in the final version, to a more general, luxurious background. Also, the profile of the warning, plotting confidante is more expressive, and the texture of the final canvas is more varied and decisive. On the whole, we can thank the Carnegie judges of 1934 for awarding the prize to Karl Hofer and not to Beckmann. Their action caused Beckmann to dig even deeper into his subconscious, to explore his own myth.

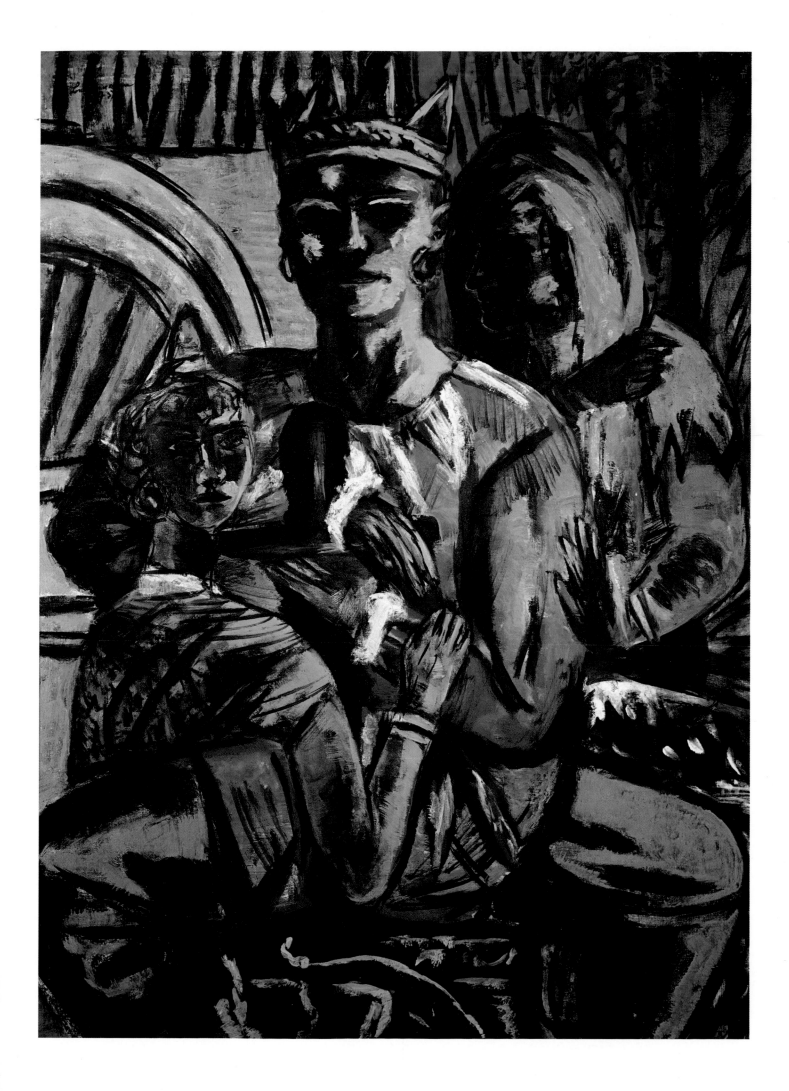

28. Landscape near Marseille

Painted 1937. Oil on canvas, 25 × 43"
Collection Margaret Lackner, Santa Barbara, California

Beckmann's landscapes are not as well known as some of his figure paintings. Hundreds of pages have been written about the great triptych *Departure* (colorplate 21) and his other allegorical works. Histories of art tend to reproduce Beckmann's mythical compositions, never his equally important landscapes or still lifes. Perhaps writers about art find it more stimulating to pursue the labyrinthine philosophical implications and mythological associations of his works, more meritorious to present their own solutions to the many riddles of Beckmann's *comédie humaine*. One can observe a landscape, in nature or in art, and say, "This is beautiful." But such a statement does not adequately fill up the allotted space in an art encyclopedia.

Nevertheless, Beckmann's rural and urban views of Germany, Holland, France, and, finally, of America provide the spectator with much food for thought. The characteristics of these countries, seen through a Germanic temperament, are revealed in a penetrating way. Beckmann's passionate love for the visible world becomes most obvious in his landscapes. The mature Beckmann was not an outdoor painter; only in his youth did he go into the countryside with easel, canvas, and paint box like the Impressionists. He made occasional charcoal and pencil sketches while traveling, but he usually relied on his excellent memory. At times I witnessed his amazing visual recall. He loved automobile excursions but did not drive himself, so I often chauffeured him through Paris and the French countryside. Sometimes I saw him press his eyelids together like the shutter of a camera. Several months later, visiting his studio to view his latest works, I would recognize a site of which he had taken a mental snapshot.

Landscape near Marseille must have been observed several years before it was painted in Amsterdam. The bridge, the shoreline, and the islands are represented correctly. The long gestation period did not diminish the freshness of the colors or design. The azure hues of sea and sky have the frail, lovely sheen of a butterfly wing. The composition is admirably solid. An S-curve, starting with the rock in the left foreground, continues along the railing, the bridge, and the shore drive of the peninsula to the horizon, leading irresistibly to the farthest distance. One feels the painter's insatiable appetite for the glitter and glory of the natural world.

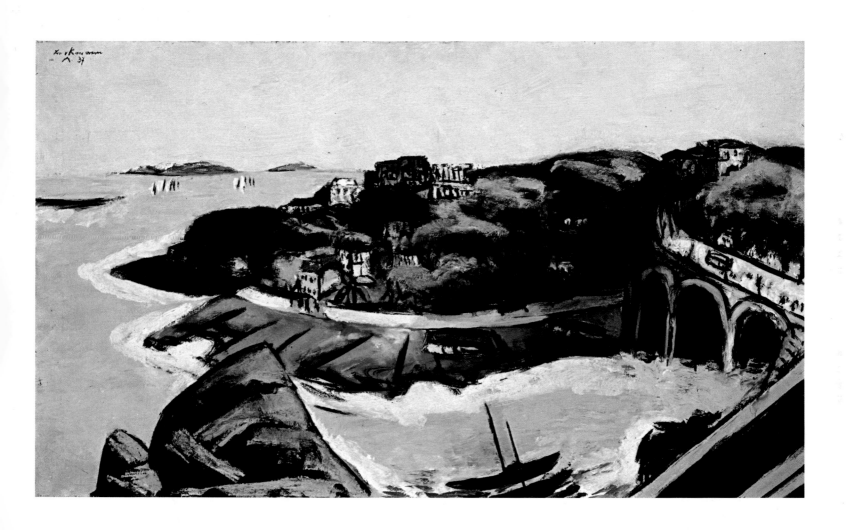

29. Quappi with White Fur

Painted 1937. Oil on canvas, 42 7/8 × 25 1/4"
Private collection, Munich

For the painter Beckmann, his wife Quappi was always *the* lady. He had no qualms about representing himself as a clown, a carnival barker, a proletarian, or a gentleman—whatever his artistic intentions required. But Quappi's countenance, in the mirror of her husband's art, was always ladylike. Even in costume, or when her features appear in a triptych in the context of a mythical story (*Departure*, colorplate 21), she is of noble character, a queen or a supplicant gently striving to improve the lot of other human beings.

This 1937 portrait of Quappi is the most elegant of all. What an enchanting little lady, slim and trim, and quite happy to be admired. With hat and gloves and fur she illustrates what the well-dressed woman wore during that particular season. She appears as a creature of the moment, and even the dating of the painting emphasizes the transitory nature of the scene: it states very explicitly, *Quappi Beckmann, 10. 12-1937, Amsterdam*, an exact inscription that is unique in Beckmann's work.

Is *Quappi with White Fur* just an ephemeral apparition, caught accidentally like a lovely insect in the amber of high art? The charm of a fashion plate is certainly there; but charm also implies magic, and the magic of Quappi's deep, dark eyes makes us think of a timeless sphinx. The careful recording of that one day—December 10, 1937—can be understood as a warning: *Carpe diem*, squeeze out of this short day whatever enjoyment you can, for we are wanderers in exile, and nobody knows what further tribulations fate has in store for us.

The little Pekingese dog, Butschi, was part of the Beckmann's household through several decades—not, of course, always the very same animal, but the soul of the same ancient Chinese sage in the shape of a grouchy little monster. In the painting, its silken fur blends perfectly with the distinguished appurtenances of the fashionable lady. Several shades of pink in the background underscore the lightness, the delight of that hour.

The virtuoso brushwork heightens the impression of a lucky, momentary inspiration. Everything is jotted down alla prima. The texture of the pigment captures directly the surfaces of the objects—for instance, the little knots in the veil and the deep pile of the white fur piece. Almost by sleight of hand, the soft, pliant hairs of the brush produce a dog's tail of exactly the same consistency.

Should we, then, reproach this work for being too facile?

There is an old story about the Japanese painter Sesshū that has some bearing here. A prince had promised Sesshū a thousand pieces of silver for a painting of a rooster, but when the artist put it on silk in the presence of his patron within five minutes, the prince complained: such a brief effort was not worth the high payment. Smiling, Sesshū slid open the door to the next room, which was overflowing with sketches and studies for this same rooster. No wonder that the final execution of the painting looked playfully easy.

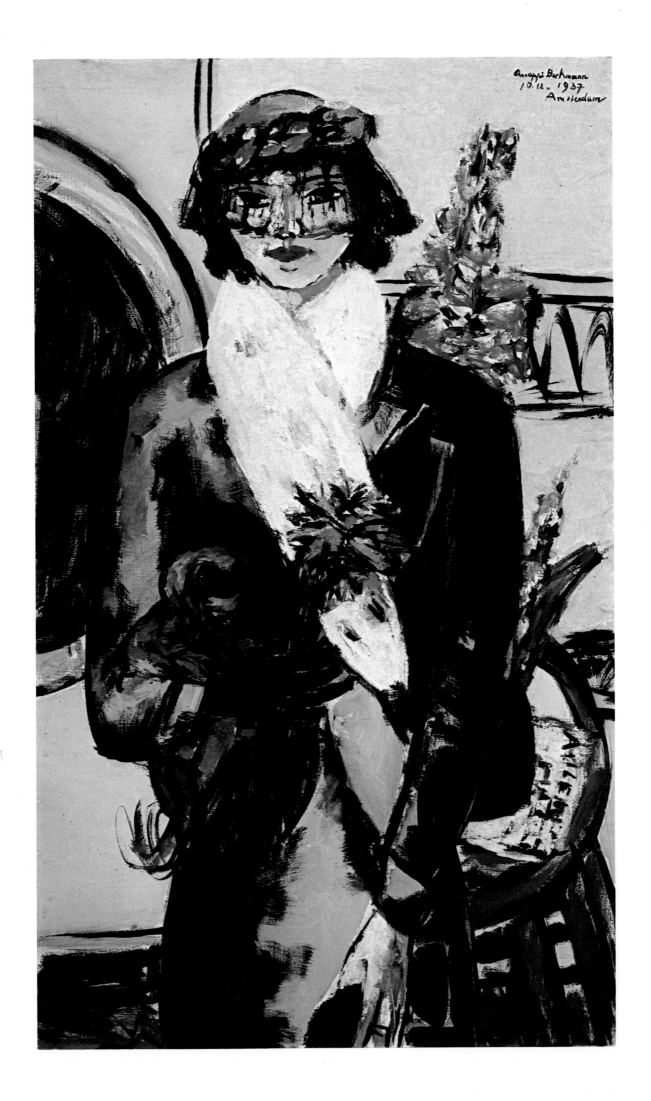

30. Self-Portrait with Horn

Painted 1938. Oil on canvas, 43 1/4 × 39 3/4"
Collection Dr. and Mrs. Stephan Lackner, Santa Barbara, California

In *Self-Portrait with Horn*, a very lonely man stares out of the canvas. The painting is among the most melancholy, and perhaps the deepest, of Beckmann's many studies of his own persona.

The man does not look at himself in the mirror, nor at the spectator before the canvas; his gaze follows the resonance of a horn call, which he has just sent out like a message. He seems to listen for a distant echo. But there is no response, only a great silence.

Here is a man forsaken by his time. No furnishings, no amenities of civilization, just an empty frame remains behind him. His strange, timeless costume seems to combine harlequin and convict associations. The richly colored stripes are a marvel of pure painterly accomplishment, almost reverting to some organic phenomenon of nature. Their rippling rhythm is reminiscent of sound waves; their full, soft color corresponds to the timbre of the horn call. The heavy, clumsy hands are half bound to nature's clay. These simple hands are a far cry from the thin, expressive, nervously articulate hands that the artist used to invent between 1917 and 1923. Most of the male hands that Beckmann painted from the thirties on are graceless but of stupendous vitality; the fact of their being there seems an overwhelming statement concerning the persistence of life.

The huge face, overshadowed by reticent sadness and foreboding, knows all about the troubles of existence. And yet, the man still listens to the dying horn call of Romanticism, and never gives up expecting the transcendent echo.

This is a man who has seen through the petty quarrels, and the hustle and bustle of everyday existence, and is now searching for the essence of life. Thus, the painting is reduced to bare essentials: the man, his horn, and a golden picture frame surrounding the head. What is the meaning of this square halo? Perhaps it signifies that the man has transcended the picture frame, that the exclusive sphere of art has become too small for him?

And what about the horn? In German literature and painting, the *Waldhorn* was a specific symbol of Romanticism. The basic collection of German folk songs undertaken during the Romantic period was called *Des Knaben Wunderhorn*; many artists, including Gustav Mahler, used the horn for romantic effects. It is doubly touching that a

dour, sarcastic man like Beckmann should picture himself with this romantic attribute. The newly exiled artist, cut off from friends and homeland, was evidently immersed in nostalgia.

Beckmann's persistence in working out a certain idea was phenomenal. In 1909 he had seen the painting *Halali* by Gustave Courbet, in which a party, after a successful hunt, is being called together by the sound of a hunting horn. Beckmann wrote: "A strangely quiet, concentrated mood pervades the painting. The *piqueur* becomes a symbolic figure as he blows his triumph out from the picture. Something like renunciation after a beautiful, clear victory emerges." The same mood prevails in *Self-Portrait with Horn*, painted thirty years later.

An earlier stage of this work—which has been preserved in a photograph (fig. 34)—presents a mysteriously smiling face, apparently enchanted by the horn's melody. Later on the bitterness of the times overcame the artist. With Hitler at the gate there was really nothing to smile about. Thus, we have been deprived of what would have been the only smiling self-portrait from Beckmann's mature years. In 1910 he had portrayed himself grinning over a newspaper; he had just been "panned" by an art critic, and this amused him. His other self-portraits show him earnest, proud, grieving, or cocky, overwhelmed by self-doubts, or cynical, but never again smiling.

A comparison of the first version with the final result reveals the workings of Beckmann's artistry. He added the red curtain on the right, cutting the horn's bell in half, for the sake of equilibrium. The gesture of his right hand, which originally pointed in the direction of the music, became more reticent. Several circular shapes in the early version evoked thoughts of the harmony of the spheres; these have disappeared, and the picture has grown earthier and more somber. The corners of the mouth now turn down under the weight of sorrow and disappointment; bags have appeared below the eyes, indicating a sudden aging. The whole work has gained in intensity and concentration.

The echo that this genius listened for, in vain, for so long can now be heard, and it grows even stronger as time passes by.

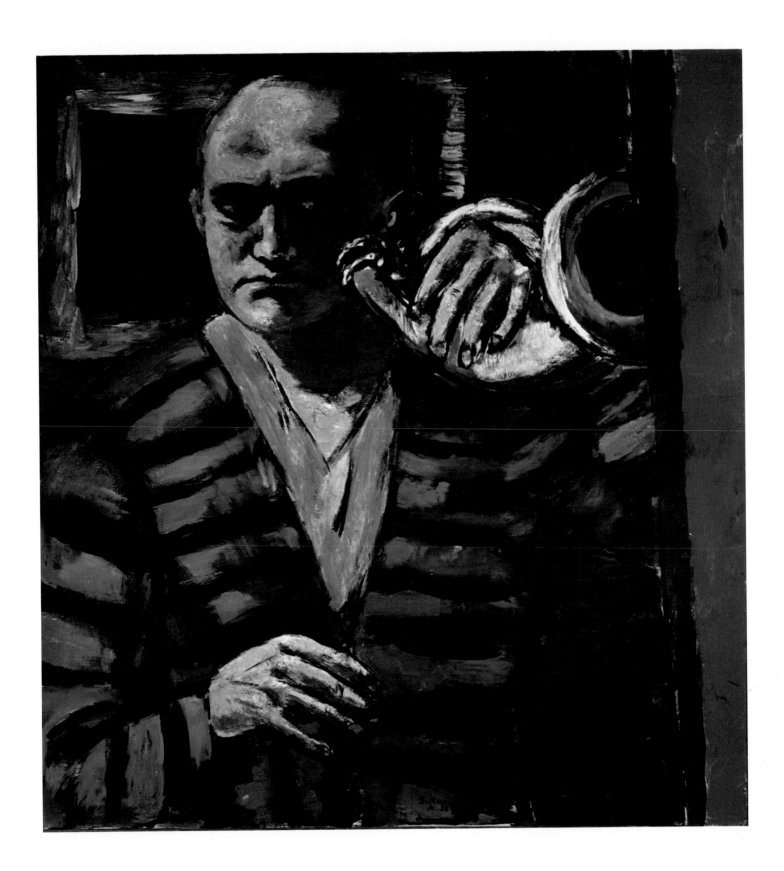

31. Portrait of Stephan Lackner

Painted 1937–39. Oil on canvas, 28 1/2 × 21"
Collection Dr. and Mrs. Stephan Lackner, Santa Barbara, California

It is difficult to look at one's own countenance objectively, especially after a third of a century has passed. A certain nostalgia cannot be suppressed; memories of a deep friendship with the painter seem to cloud the analytical eye of the art historian. But perhaps a work of art should never be observed with absolute coolness.

Max Beckmann and I were friends from my student days in Frankfurt to the time of his death in New York in 1950. In 1933, when the Nazis forbade his art to be exhibited, I acquired my first "Beckmann," and I have endeavored to further the cause of this great and often misunderstood artist by collecting his work and writing about it ever since.

In 1937, when he left Germany, he visited me in Paris, and it was natural that we should have discussed a commission to paint my portrait. I do not know when the plan took final shape in Beckmann's mind. There were no formal sittings. Once, when we drank coffee on the terrace of the Café Georges V, I noticed that he scribbled something on the back of an envelope, which may have been the first sketch. And sometimes I felt his penetrating gaze persistently scrutinizing my face, which would have been uncomfortable had I not known about his artistic intention.

Beckmann usually finished his portraits from memory, as was the case with *Portrait of Stephan Lackner*, which he completed in 1939 after I had already gone to America.

The face is the only part of the picture that has been worked over with many layers of paint, showing more modeling and detail than the rest of the canvas. This emphasis corresponds to the psychological effect we often observe when we glance at a person and perceive the face more distinctly than the dress and the background.

An earnest, slender, idealistic youth is presented in strict frontal view, which produces a somewhat formal appearance. The Eiffel Tower, seen through the window on the right, and the white flowers on the left were executed in almost stenographic abbreviation. The hands are holding a book with a protective gesture, which behooves a writer who has emigrated from Nazi Germany. A few capital letters appear on the book's cover: TIER and NER, which stand for *Der Mensch ist kein Haustier* (*Man Is Not a Domestic Animal*) and Lackner. The artist had just illustrated my book of that title with seven lithographs. Beckmann liked my work; he discovered in it a "seltsame Affinität der Zustände" (a strange affinity of the states of our souls).

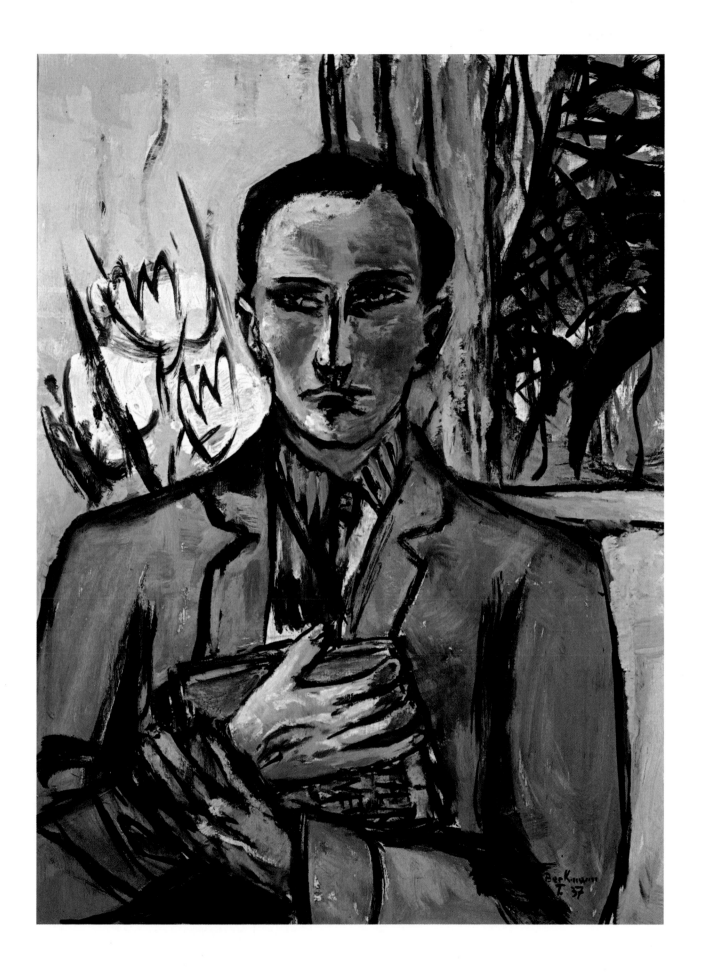

32. The Rainbow

Painted 1942. Oil on canvas, 21 5/8 × 35"
Private collection, Germany

A pleasant, gentle spring day on a Dutch riverbank. The rain has just passed; the flowering fruit trees seem freshly washed; a brilliant rainbow crowns the wooden bridge. Peaceful and gay, nature receives the visitor who has left his constrained and sorrowful city existence for a few hours.

Even the little railway train appears as part of nature. When the railroad first burst into the idyllic realm of art, it was as a messenger from the "black, satanic mills." J. M. W. Turner's Great Western locomotive was a demon, an irresistible new force on its way to change the world. Beckmann integrates this intruder quite nonchalantly with the environment he has created. He does not want to idealize; he finds poetry even in the modest plume of fire and smoke. In this painting art has come to terms with the technological age.

Beckmann's rainbow looks like a manifest of spring, fresh and rare and dewy. The order of the colors is not naturalistic; they are intermingled like blossoms in a random bouquet. When other artists—Rubens, Caspar David Friedrich, and Franz Marc come to mind—painted rainbows, they adhered to the natural spectrum as a matter of course. Beckmann's is a surprising, personal rainbow charged with sudden happiness. The sweep of the artist's brush is more important, more expressive than naturalistic "correctness."

Generally, Expressionists wanted to represent two completely different phenomena at the same time: the motif and their own egos. Zola had defined art as "a corner of nature seen through a temperament." The Expressionist school turned this definition around: art exists when, through a picture of nature, a personality is perceived. The way a river, a tree, a rainbow are painted gives the viewer quite a bit of information about the painter and his quirks, his preferences, his horrors, and his delights.

Since none of the many divergent characterizations of Expressionism has been entirely successful with the critics, I want to add my own definition: The Expressionist style prevails when the brushstroke can be understood graphologically. When a painted curve on a canvas follows the inner tensions of the individual while he is painting, rather than following the contours of an object quasi-photographically, then we are in the presence of an Expressionist work of art.

Beckmann's personality—gruff, reticent, prickly—is expressed in the "handwriting," especially of the dark trees. But the lyrical beauty of the rainbow and of the flowering trees must have been germane to his character, as well. Otherwise he could not have expressed this delight.

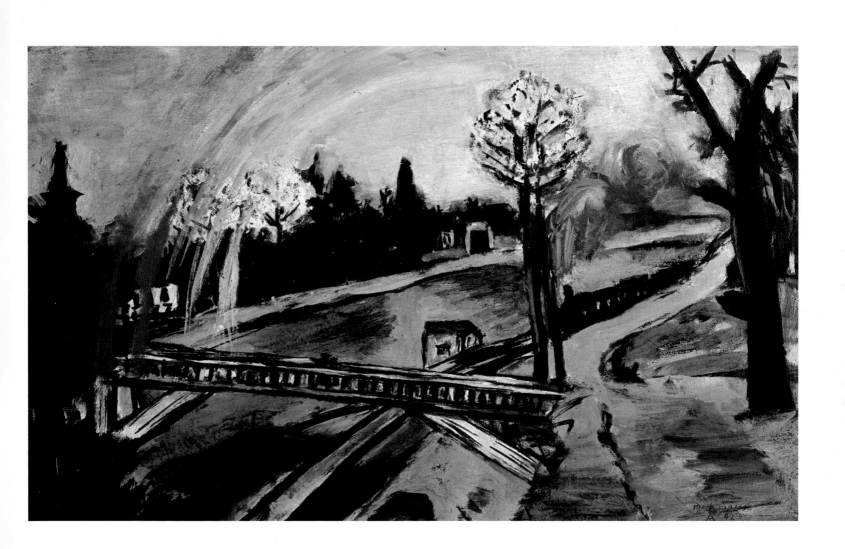

33. Odysseus and Calypso

Painted 1943. Oil on canvas, 59 × 45 1/2"
Kunsthalle, Hamburg

Calypso, the beautiful and voluptuous nymph, holds the shipwrecked Odysseus captive on her island. He reclines on her luxurious bed, surrounded by her silently menacing animals, dreaming of escape. His sword rests behind him on the pillow, and his shins are protected by armor. He was probably planning his escape, and Calypso has surprised him. In a gesture of hopeless waiting and futility Odysseus folds his arms behind his head. The nymph, all tender persuasion, snuggles up to the gruff warrior, promising him perpetual youth and even immortality if he will only remain with her. But the luxurious surroundings have no attraction for the old voyager. Sullenly he dreams of his homeland. "To see once more the smoke rising from Ithaca's hills and then to die" is his only wish—one which the lovely woman cannot fulfill.

Beckmann, after years of exile, must have had many moments of burning homesickness. In his diaries he called himself "pauvre Odysseus," and in letters he referred to his life as "my Odyssey." But this painted Odysseus of 1943 is not a self-portrait. Only the tense atmosphere of waiting mirrors Beckmann's own experience.

The brushwork is fluid, firm, and ample. The artist knows exactly what he wants and has found the most concentrated formulation for his thoughts. *Odysseus and Calypso* may be called the first work of Beckmann's last creative period. Clear, strong, brilliant colors are a hallmark of his late style. They fill their contours without interior variations. The color gray becomes infrequent; as an admixture to other colors it disappears from Beckmann's palette. The effect is somewhat akin to a violinist discarding a sordino from his instrument. The late works of Beckmann have an almost shocking directness.

The black outline—which has been called Beckmann's trademark by several art historians—now reveals his bodily force and temperament. When Beckmann's typical black contour first appeared about 1917, it served to modulate the apparent plasticity of his objects; it contracted to knife-sharp thinness at the lighted side and expanded softly into the shadows. In the mid-twenties it became the structural skeleton of his composition. In the thirties it clearly divulged his very first stroke on each canvas; he painted, sometimes laboriously, around his primary black sketch and often left large parts of the original underpainting untouched. Finally, in the forties, the black line became his personal shorthand to capture fleeting apparitions.

Confined to cramped quarters in Amsterdam, forbidden to travel, suffering from all kinds of shortages, and menaced by the Nazi occupation forces, Beckmann found relief by escaping into the realms of fantasy and ancient mythology. After painting *Odysseus and Calypso* in 1943, he had to wait four years until he was a free man once more. But the "pauvre Odysseus" never saw his homeland again.

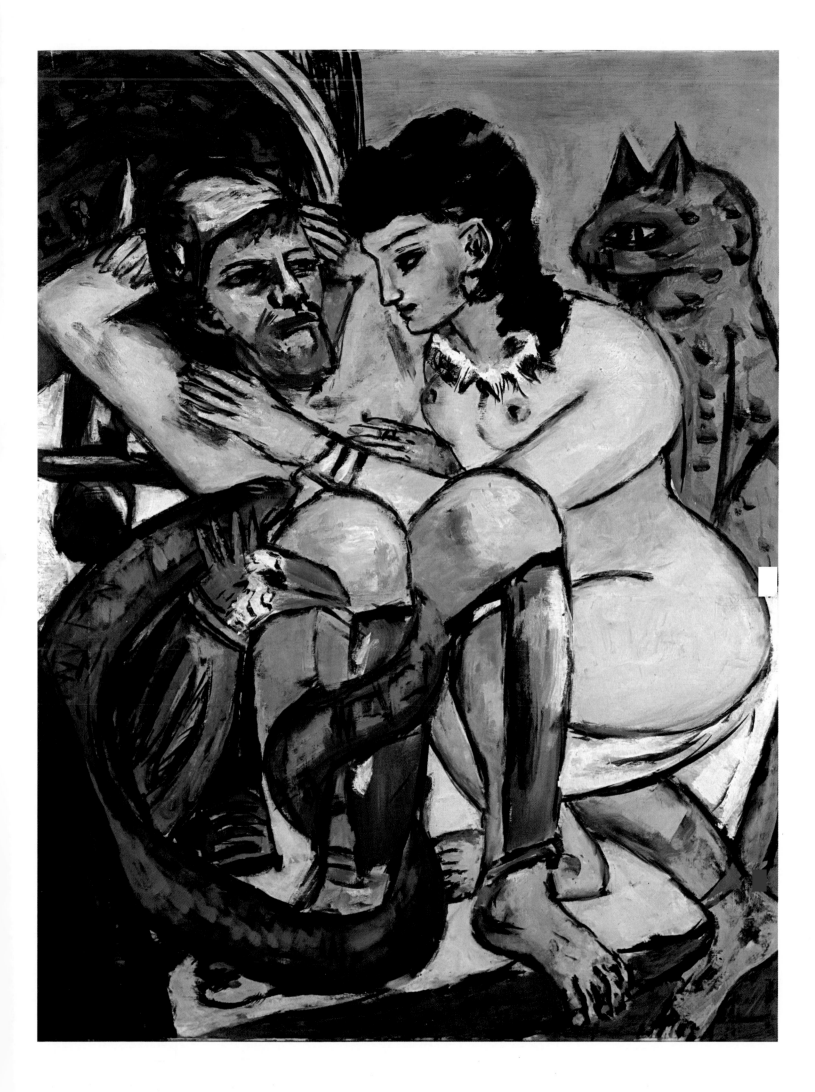

34. The Mill

Painted 1947. Oil on canvas, 54 1/4 × 50 3/8"
Portland Art Museum, Oregon

The liberation of Holland in May 1945 was not immediately a personal liberation for Beckmann. All through the war years he was in danger of being "discovered" by the Nazi occupying forces; now he was endangered by "superpatriotic Dutchmen" who wanted to ship all Germans back to their defeated fatherland. Of course he was grateful that Holland had given him asylum since 1937, but he was eager to move about more freely. Since he could not obtain a passport or visa, he made bicycle trips around Amsterdam. In his diary on May 12, 1946, he admonished himself: "Old donkey, you are pretty well off, even though you are still somewhat imprisoned in this flat ironing-board country. So be still." On May 15 he was finally able to take a few weeks vacation in the countryside at Laren.

From June 19 to July 23, 1946, as a result of this trip, he painted *Windmill* (fig. 43). With its lush, green fields and pine trees, its enormous clouds and idyllic windmills, the canvas is a declaration of love for Holland. And yet, after August 31, this lovely picture was suddenly perverted into a nightmare, and the Dutch windmill was re-created as a torture instrument. On December 15, 1946, he noted in his diary: "*The Mill* is finished, and so am I."

The basic structures of the two pictures are very similar. In the later painting the arms of the windmill have become a rack on which several well-dressed, obviously normal people are being bound like criminals and senselessly whirled around. The white, round clouds in the background of the earlier version have turned into aerial balloons, and the bicycle at the lower left has been magically transmuted into a reddish balloon; escape has become the painter's wish-dream. The formerly peaceful farmhouse in the middle ground is now going up in flames. The earlier painting showed a gable and a gentle Dutch couple on the left; in the later version the space is dominated by a cage in which three or four men and a kneeling woman are handcuffed and crammed together.

The redheaded, half-clad, helpless girl has an extraordinary, touching beauty. Her arms cross those of the standing man and together they parallel the windmill's sails, which complete the unified pattern. It is a composition of cross-purposes, whose tyrannically imposed order, for each individual, amounts to senseless slavery. The windmill, in this second painting, seems to have acquired the shadowy face of a demon.

What is the explanation for this cruel deterioration of that bucolic Dutch motif, the windmill? Beckmann's memories of the Nazi era may have welled to the surface. His fight for a "non-enemy declaration," his bad health in consequence of the war years' deprivations, and his immobility and helplessness in the coils of bureaucratic red tape had a disastrous effect on his nerves. And yet, these petty hindrances, even though they amounted to personal torture for the old freedom fighter, cannot elucidate the deeper contents of the artist's soul.

Beckmann's esoteric symbols have been well analyzed by Friedhelm Fischer. A clue is given in the half-illegible message underneath the cage: BRASITH ELOHIM. These words—the beginning of the Book of Genesis—open up a mythical perspective. Beckmann, a well-read man, knew much about Vedic, Platonic, and Gnostic myths. He studied Schopenhauer, and Madame Blavatsky's somewhat confused "Secret Instruction." Accordingly, the cage on the left may stand for the imprisonment of the human soul in fated worldly concerns, and the whirling mill may symbolize reincarnation through eternal cycles, the inescapable metempsychosis of Indian lore. Even the peaceful meadow seems to have undergone a sea change; it resembles a deluge.

Pinning down the artist's intentions and connotations may seem a futile endeavor. He was not an illustrator of ancient myths; he himself was haunted by sometimes frightful, sometimes blissful visions. But the overwhelming forcefulness of the symbolism in *The Mill* must impress even the uninitiated beholder.

It is of more than academic interest that the Portland Art Museum bought this work as early as December 1949. Such acts of recognition helped to make Beckmann's last three years—his American years—the most enjoyable of his life.

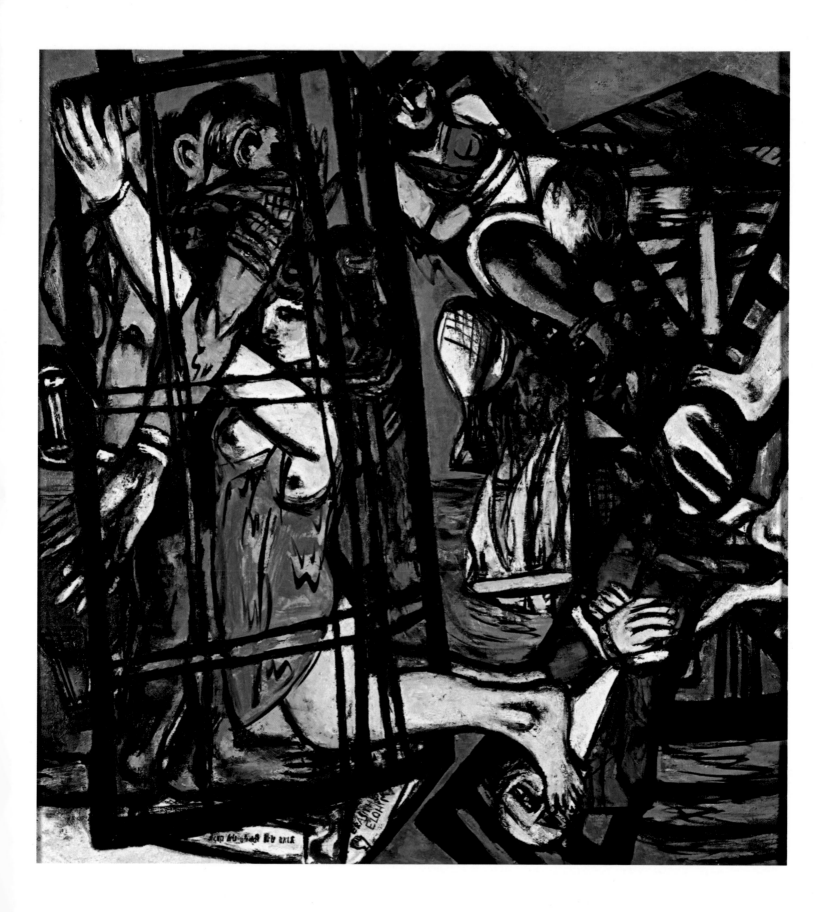

35. The Prodigal Son

Painted 1949. Oil on canvas, 39 1/2 × 47"
Niedersächsische Landesgalerie, Hannover

The prodigal son is shown here "devouring his living with harlots," according to Saint Luke's picturesque account. But his "riotous living" brings him no joy; glum and unseeing, he stares into emptiness, ignoring the goblets and the full-blown, gaudy women surrounding him.

Beckmann has chosen to represent the Biblical group in contemporary garb, just as Bruegel, Rembrandt, and many other painters did before him. This heightens the impact and the immediacy of the parable, even while removing the pale, spiritual veil of the "Bible story." The encounter sparkles with color and life.

The three young, seductive ladies differ widely in appearance. The figure on the right has a typical Egyptian profile, almost a replica of a Pharaoh's daughter from the fourteenth century B.C. The dusky skin of the statuesque, dignified Negro girl contrasts with the creamy hues of the Nordic woman who seems to claim the forlorn young man as her exclusive property. This divergence of types illustrates the Gospel's pronouncement that the prodigal son "took his journey into a far country." The exotic females, with their brilliantly colored dresses, make the lost traveler appear drab and somewhat mousy. His thoughts are roaming; is he thinking back to the strict yet comfortable ambiance of his father's house? The activities of "wasting his substance" have lost their appeal, and, obviously, he does not seem to have much substance left.

In spite of the fable's moralism, the painter's visual sympathy lies with the picturesque prostitutes. They are shown having fun; the stern old madam, half-hidden by a screen on the right, is definitely needed to remind them that this visit is a business transaction. Beckmann does not criticize these women. The moral of the tale lies in the sallow, sad face of the prodigal son and in the dejected gesture of his hands.

When Beckmann painted a "story," it expressed the current state of his own soul. This is the Expressionist element which distinguishes his art from nineteenth-century historicism. In the case of *The Prodigal Son*, we can trace this personal note very distinctly. Saint Luke speaks of a "journey into a far country." In Beckmann's diary, during the time when he worked on *The Prodigal Son*, there occurs an enigmatic, visionary sentence (St. Louis, February 9, 1949): "Beckmann at last moved to a far, big country, and slowly we saw his figure growing more indistinct. Finally it disappeared entirely in uncertain distances."

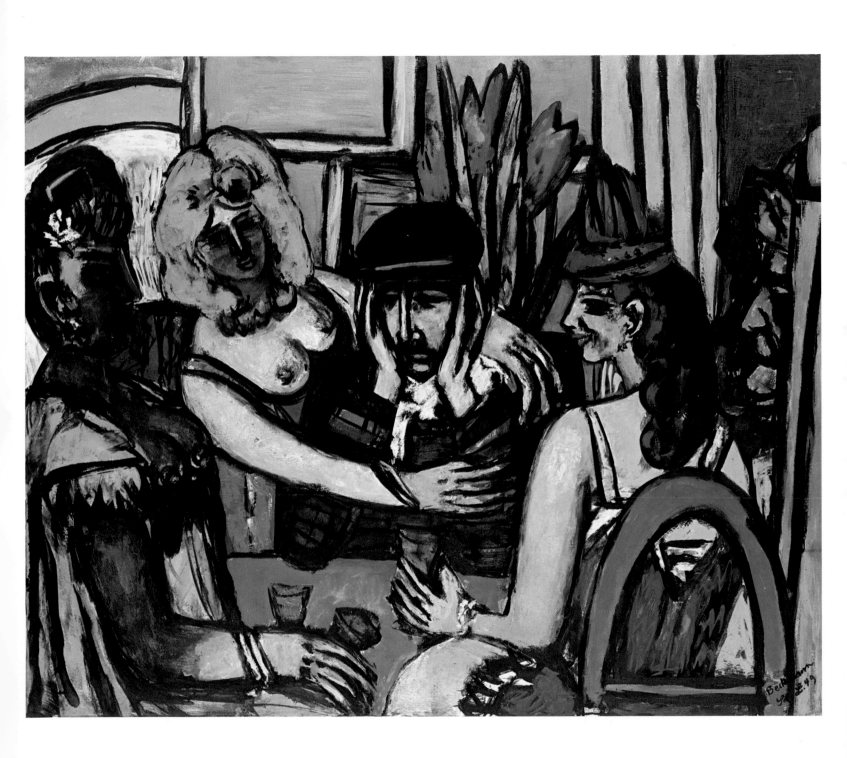

36. Portrait of Fred Conway

Painted 1949. Oil on canvas, 24 1/2 × 19 5/8"
St. Louis Art Museum

From time to time, Beckmann liked to prime his canvases with a color other than the usual white. In his *Self-Portrait in Sailor Hat* of 1926 (fig. 20), for instance, the crimson ground flickers through the contours and gives the painting an electrical charge. In fact, evidence of this underpainting appears in his last self-portrait (colorplate 39), in which the painter stands in front of a canvas primed in purple. In *Portrait of Fred Conway* Beckmann also utilizes this device; it provides the painting with a half-hidden, somewhat demoniacal tension. The purple ground remains visible along the right rim of the canvas. Hans Baldung Grien and Albrecht Altdorfer used this technique during the Renaissance to depict witches and saints. Working up to white and down to black from a grayish or colored middle ground yields an additional dash of plasticity.

When Beckmann taught at Washington University in St. Louis, in 1947, he made many new friends. Among them was his colleague at the School of Fine Arts, Fred Conway. Beckmann portrayed Conway's interesting face without a formal commission. It is a face full of character, manly, with penetrating eyes. This forty-nine-year-old painter must have impressed Beckmann as a typical American "rugged individualist." The hair, breezily spread sideways, lends a note of fantasy to the small portrait, one of the few by Beckmann that does not show the sitter's hands.

St. Louis was a wonderful place for Beckmann. He enjoyed teaching, and was lionized by intellectual and wealthy people. However, he still found time to produce a great number of paintings, including the portraits of Louise Pulitzer, Morton D. May, and Perry Rathbone (figs. 48–50). These are among his most important works, as is the Conway likeness—intense, unassuming, and yet crackling with vitality.

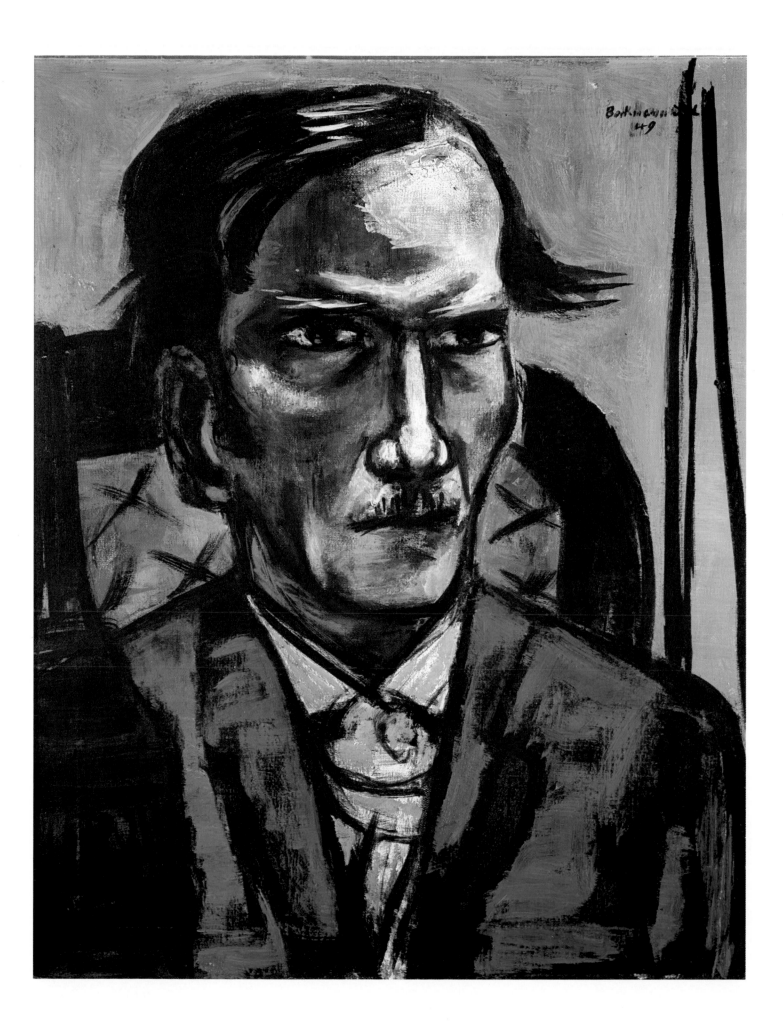

37. Girl with Mandolin

Painted 1950. Oil on canvas, 35 7/8 × 55 1/2″
Collection Otto Stangl, Munich, on permanent loan to the Wallraf-Richartz-Museum, Cologne

Musical instruments appear so frequently in Beckmann's works that one feels he may have had musical compositions in mind to accompany his painted scenes. This background music was different for each drama on canvas. In the paintings and graphics of the twenties, strident sounds seem to pervade the atmosphere: deformed trumpets, carnival noisemakers, and primitive phonographs form a harsh, sarcastic orchestration. Later on Beckmann used horns and viols, and his instrumentation became more romantic. Finally, toward the end of his life, the choice of instruments underlines a quiet lyrical beauty: very often lutes, flutes, and harps take over the accompaniment.

The young woman in *Girl with Mandolin* does not actually strum her instrument, but the music "vibrates in the memory." She has given herself over to a daydream. This is a gentle, tasteful picture; the position of the instrument evokes ever so lightly a love situation.

Beckmann was, of course, capable of much more explicit erotic symbolism. In *The Dream* of 1921, painted during his most cynical period, he depicted a drunken girl frolicking shamelessly with a cello (colorplate 6). Looking at that robust ersatz sexual act, one is inclined to contradict Dr. Samuel Johnson's famous observation that music is the only sensual pleasure which is free of all vices.

In contrast, the 1950 *Girl with Mandolin* is animated by pure poetic feelings. Her face is averted from the lute's neck as from the advances of an importunate lover. The flowering of her young body shows that she will be capable of love, but, for the moment, she takes refuge in a dream—and in silence.

A digression concerning Beckmann's relationship to music may be permitted because musical sounds were always an important part of his surroundings. His first wife was a well-known opera singer, his second wife an excellent violinist. The painter's changing taste concerning the sister art of music reveals much about his artistic aims. In 1909 he raved about a Romantic musical program: "Then came a Brahms quintet which was incredible. These wonderful sounds lifted my soul high above the pettiness and dirt of everyday life. Its grandiose, jubilant lines were like the rhythms of sea or forest when spring tempests rush through them. So much tragic feeling transfigured by powerful beauty." Beckmann shed his exuberant sentiments in World War I, and his musical friends had to play Bach for him on the piano. In 1917 he confessed: "The *St. Matthew Passion,* for me, is the most colossal thing in existence." Later on he esteemed Hindemith and Bartók, and he had an open ear for newly imported American jazz. On one of his 1924 drypoints representing chorus girls kicking up their heels he wrote in capital letters and bad English: "O no we have not bananes," showing that he was up-to-date on contemporary popular tunes. For a while he preferred gypsy music. In 1948 he waxed enthusiastic about "red rumbas which make the blood course through your veins as if to a wild dance." His reactions to sounds were as strong and vital as his receptivity of colors and forms; the audible served to heighten the visual for him.

The two senses—sight and sound—meet in the shapes of musical instruments, and Beckmann has managed by subtle transformations to express their characteristic tones in the mellow curves or sharp angles of their various designs. In the 1950 painting, the mandolin resting on the girl's body has a birdlike quality, faintly reminiscent of Leda's swan. The young woman steeped in reverie is presented with an almost classical loveliness of design. It is a quietly serious, thoroughly mature painting—the work of an elderly man who has learned that some of our best wish fulfillments have to belong to the realm of dreams.

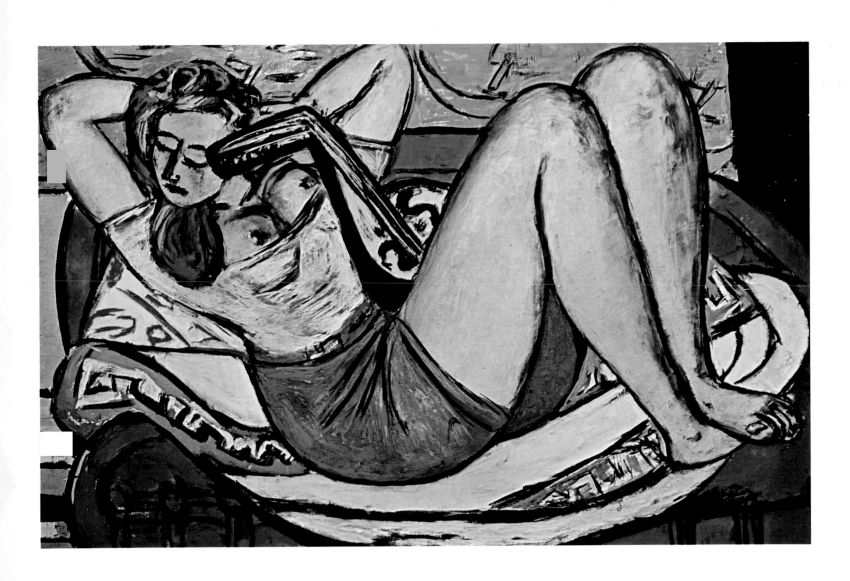

38. San Francisco

Painted 1950. Oil on canvas, 39 3/4 × 55 1/8″
Hessisches Landesmuseum, Darmstadt

Beckmann always managed to create. Even while he traveled, he often thought about his work in progress and made sketches for future paintings.

On August 13, 1950, he drew a wide-angle view of San Francisco across two pages of his diary. His entry for that day reads: "Was at last really in San Francisco and saw astonishing things which I'll probably paint." This fountain pen drawing became the basis for the large oil which he finished in his New York studio on September 7. "Beautiful ornament," he then called it in his diary.

It is that, of course, and more. The city of the Golden Gate is transformed into a gigantic, living organism. The superhighway in the foreground becomes an artery that carries the dynamic life force in a crescent-shaped sweep through the pulsating, vibrating heart of the metropolis, and on across the bridge into the farthest distance. This crescent is caught up and countered by the half-moon high above the sea; they are joined into a dramatic S-curve which binds the composition together.

"Works of art of this kind lend the eyes of their creator to the beholder," Günter Busch has observed. Indeed, the bays, skyscrapers, and hills of San Francisco seem to have changed when we view them after absorbing the thrill which Beckmann felt and expressed on canvas. He had a remarkable ability to formulate the character of each country and city that he visited. The happy and bold curves that comprise Sacré-Coeur in Paris have, in Beckmann's treatment, expanded the concept of what is typically Parisian, and his views of the Dutch seashore appear as the embodiment of the cool Dutch character. The exquisite natural beauty of the Côte d'Azur could not have been seen in such an adventurous way by a mere native. It remained for Beckmann, the restless foreign wanderer, first to perceive and then to crystallize the wide-open, grandiose space and spirit of San Francisco.

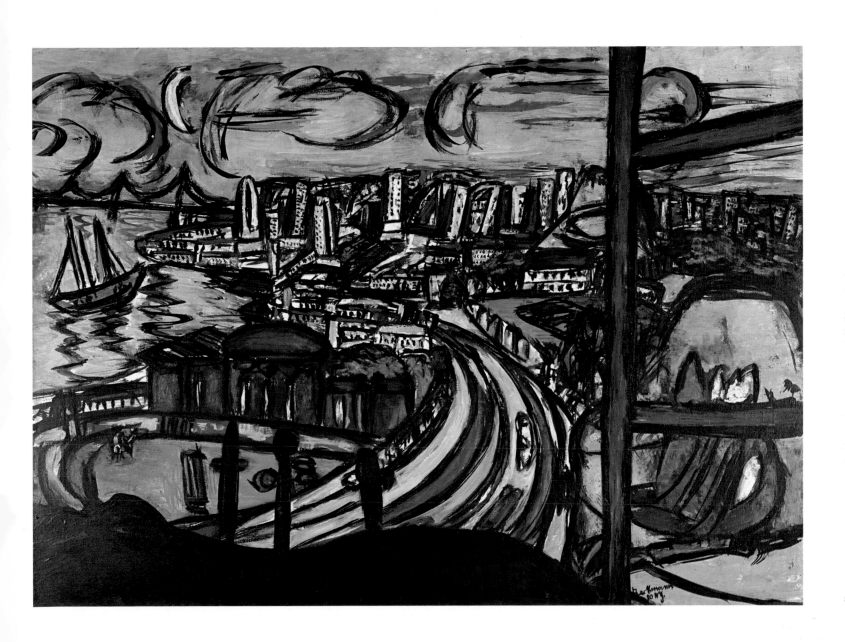

39. Self-Portrait in Blue Jacket

Painted 1950. Oil on canvas, 55 1/8 × 36"
St. Louis Art Museum

The masked ball is over; the mythological crown has been discarded. Even the tuxedo seems too fancy now. The actor has taken off his last disguise and stands before us as a human being.

There are no artifices, no frills; the far-reaching associations that were conjured up by the costumes and props of earlier self-portraits are gone. The design is as simple and straightforward as possible. The strangely crude, luminous blue of the jacket extends, unchanging, to the contours. It clashes with the bright red shirt, the green chair, and the purple wall. Here we find no softening of contrasts, no "taste" in the Parisian sense, no pastel shades like those the artist employed about 1930, and no Expressionist angularity and distortion. Beckmann proves that he "can do without"; he stands alone in the transparent dusk, not of old age, but of the maturest phase of middle age. He had no presentiment that this would be his last self-portrait, but it looks like a quiet summation of what went before.

With tie and fashionable lapels Beckmann accommodates himself to his human surroundings. The cigarette is still there, a small indulgence which he knew was bad for his heart, but what would life be without the tiniest vice? The background is stripped to bare essentials: only the rim of a canvas, on which he has painted a purplish ground, is visible—the painter's last attribute. The stretcher, with its nails, and the chair are standing straight. This uprightness is a characteristic of Beckmann's "American period."

Twelve years earlier, in *Self-Portrait with Horn* (colorplate 30), he had deemed it necessary to add a slanting edge, and in his pictures of the twenties, perpendicular and horizontal lines were almost taboo. Often he added a sloping ledge, a sharply inclined frame or windowsill, just to break up any suggestion of a rectangular grid. These crooked frames of reference seemed to say: You, the spectator, have lost your equilibrium; it is up to you out there to restore the balance of the world.

The earlier paintings deformed each right angle of a building, shunning any comfortable, conservative organization, tilting all things to fit the typical, non-Euclidean Beckmann space. The last pictures have no such prohibitions. They include the right angle as well as any other.

Beckmann must have felt that a return to normalcy was possible in this country. America had a stabilizing influence on his art; self-confidence came back to the refugee. The warm acceptance accorded him by the people of his new homeland calmed his political forebodings and his cosmic fears.

If the old scowl still lingers around the eyebrows, it is because Beckmann remained Beckmann. His penetrating eyes still see the incredible magic of life, but for the moment, for the duration of creating this self-portrait, he has renounced his conjurer's power. These are the eyes of an elderly Prospero who wants nothing more than a little peace.

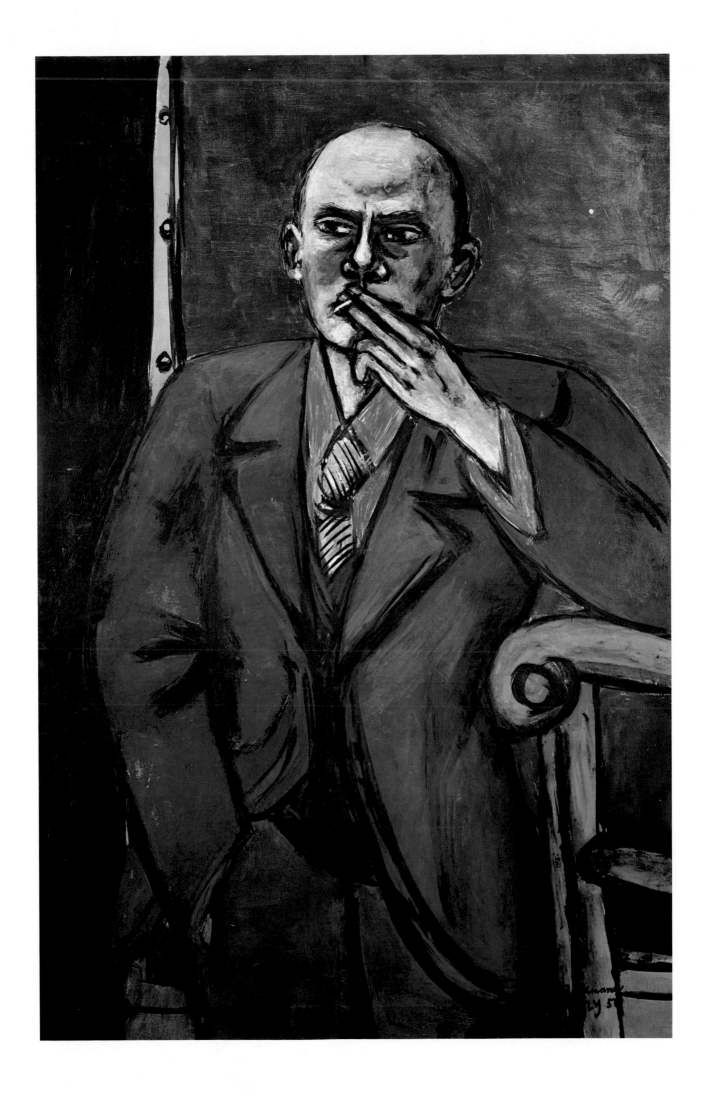

40. The Argonauts

Painted 1949–50. Oil on canvas; triptych, center panel 80 1/4 × 48″; side panels each 74 3/8 × 33″ Private collection, New York

The nine triptychs that Beckmann created are an incredibly rich and varied repository of pictorial ideas and visions. Their form is a revival of the medieval altarpiece, a shrine whose wings were closed except on holidays when its gospel lore and legends of saints and martyrs were revealed. This historical connotation explains why the wings of Beckmann's triptychs, although they do not close, are usually much narrower than the center panel (see *Departure* and *Temptation*, colorplates 21 and 24).

The Argonauts is the most serene of Beckmann's post-Christian altarpieces. The earlier triptychs show many tortured, shackled, and maimed people, as well as some who are deceived, sadistic, and simply foolish. The figures in *The Argonauts* are healthy, self-reliant, and enterprising. The elements of lust and baseness were required in the earlier works to set off the spheres of the persecuted hero and the confused dreamer; now, in the last work, the hero as a dreamer—or the dreamer as a hero—has conquered the nightmarish aspects of life. Thus, in retrospect, *The Argonauts* triptych appears as the logical conclusion of Beckmann's lifelong "passing show."

Beckmann initially called this work *The Artists*. The bearded, intense, contemporary artist in the left panel—not a self-portrait—was the first figure that Beckmann envisioned. Perhaps he saw this painter as the prime mover of the entire phantasmagoria, in whose mind a modern model is transmuted into the classical figure of Medea. The artist knows that the head on which the woman sits is only a hollow mask, not really a decapitated Greek, and that the sword is but a studio prop. The girl musicians in the right panel are already half-transformed into an antique chorus. In the center panel, the fantasy is victorious; there is no trace of present-day métier left, no smell of studio dust and oil paint, only the clear, salty breeze of antiquity. Art has conquered the prosaic everyday.

The center panel illustrates, quite faithfully, an episode from Greek mythology. Beckmann had read Goethe's translation of an account by Philostratus from the third century B.C. concerning the Argonauts' voyage to the Black Sea. The young heroes Orpheus and Jason are shown embarking on their search for the Golden Fleece. Orpheus, by his song, has calmed the wild sea and has put down his lyre on the sand. The ancient sea-god Glaucus emerges from the waves to prophesy the fate of the bold travelers; their magic ship, the *Argo,* will carry them safely to the mist-darkened kingdom of Colchis where they will "liberate" not only the Golden Fleece but also the king's

daughter, Medea. This tale is a reflection of the historical first expeditions of the seafaring Greeks to barbarian lands.

Beckmann, to heighten the portent of the sea-god's prophecy, shows sun and moon darkened by a miraculous eclipse and new planets being born. The cosmic menace does not distract the keen youths from their purpose, and the ancient prophet points the way to their heroic, and finally tragic, pursuit. Accept your fate, he seems to admonish them, fulfill your task.

This triptych recalls some of Beckmann's very early pictographs: the darkened sun had already appeared in *The Descent from the Cross* of 1917 (colorplate 4). The ladder, one of Beckmann's favorite symbols, led nowhere in the early *Dream* (colorplate 6) and thus made cruel fun of a poor mortal searching for an exit from his misery; in *The Argonauts* the ladder rises out of the primeval ocean straight up into blue eternity: there is a way out, it proclaims.

But the most touching reminiscence is the reprise of the "golden youths" from Beckmann's first large-scale oil painting, *Young Men by the Sea* of 1905 (fig. 4). This composition owes much to the art student's admiration for Luca Signorelli and Hans von Marées. The maturing Beckmann often came back to the gestalt of the slender, dreamy youths with their unselfconscious charm. The center panel of his last work presents them again: thoughtful, willing to risk much for a great purpose, manly, and radiant with the bloom of youth. Forty-five years of relentless artistic effort resulted in this seemingly spontaneous personification of the élan vital.

Through much of Beckmann's career, critics objected to two supposed characteristics of his art: brutality and sex. Beckmann never quite knew why they singled him out, for sex and violence seem to pervade the huge battle scenes and the depictions of rape and martyrdom in so many museums of the world. Beckmann used to say to me, somewhat naïvely: "Really, I only wanted to paint beautiful pictures." In *The Argonauts* this intention is undeniably fulfilled. There is no violence here, and sex, too, has disappeared. The center panel is restricted to male figures, the right to females exclusively. This separation of the sexes, very rare in Beckmann's work, gives an atmosphere of otherworldliness to *The Argonauts*. Eros and aggression, which are the heritage of the human psyche, are sublimated into a spiritual adventure. A glowing love of beauty and harmony prevails in the end.

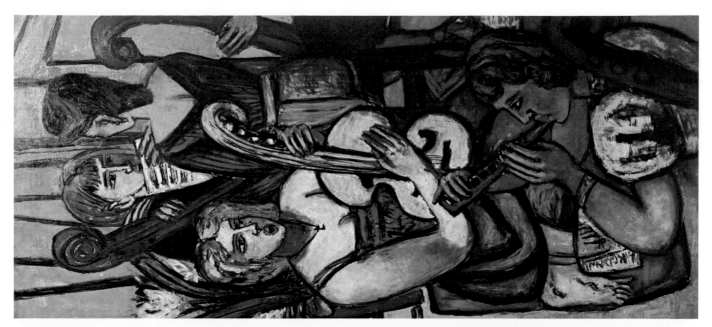

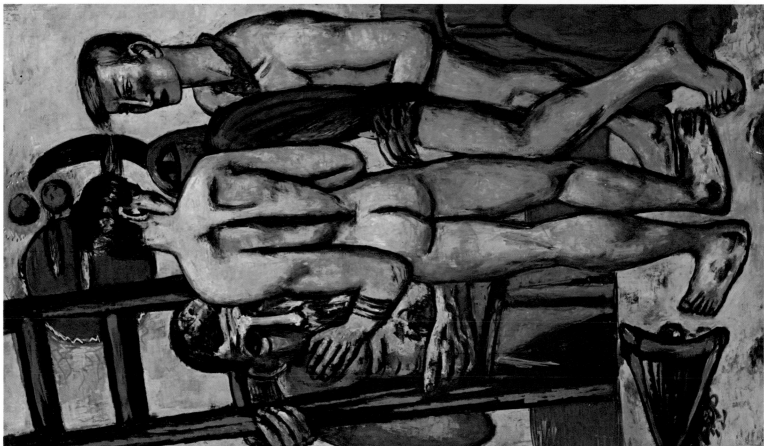

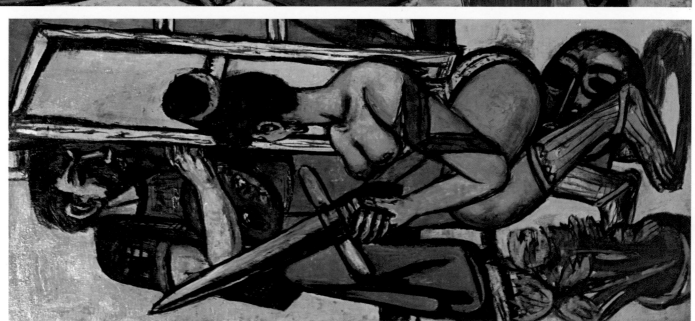

Photograph Credits

All the photographic material used in this book was supplied by the author, and the Catherine Viviano Gallery, New York, except for the following whose courtesy is gratefully acknowledged: